SECR CHESTERFIELD

Richard Bradley

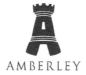

AMBERLEY

To Mum and Dad, Sheila and Keith, two North East Derbyshire natives, for all their love, support and encouragement over the years; and more recently, driving me around the suburbs of Chesterfield in order that I could photograph observatories, oil wells and ice-cream factories.

First published 2018

Amberley Publishing
The Hill, Stroud
Gloucestershire, GL5 4EP

www.amberley-books.com

Copyright © Richard Bradley, 2018

The right of Richard Bradley to be identified as the Author of this work has been asserted in accordance with the Copyrights, Designs and Patents Act 1988.

ISBN 978 1 4456 6260 2 (print)
ISBN 978 1 4456 6261 9 (ebook)

British Library Cataloguing in Publication Data.
A catalogue record for this book is available from the British Library.

Origination by Amberley Publishing.
Printed in Great Britain.

Contents

Introduction

I will begin with a confession: I am not actually a native of Chesterfield, having grown up 10 miles away in the tiny rural hamlet of Oaker at South Darley, near Matlock. However, most of my family hail from the town and its surrounding area. My mum is from Hillstown near Bolsover, and my dad grew up at Doe Lea and Glapwell. My dad's mum was from (New) Brampton, and my grandparents on that side ended up living at Hasland. Both of my grandads worked in the mining industry, which in former days dominated the area. Grandad Owen King worked at the Coalite plant (where my parents met when they were both working in the administrative offices. Coalite has attracted much criticism over the years, but personally, I owe them my existence!). My paternal grandad, Joe Bradley, was a talented footballer. He scored six goals for Glapwell Colliery FC during a 1936 match against Skegby Villa, which Glapwell won 12-1, and had trials for Chesterfield FC, cut short by the onset of the Second World War. However, his working life was down the pit where in 1970 he took over as Glapwell's Union Treasurer when the previous holder of that role left to take up a new job. That person was a certain Dennis Skinner, and his new job being the Member of Parliament for Bolsover (a position he has held for the subsequent forty-eight years). During the course of my research for this book, I was also to discover through a chance meeting with my dad's cousin Janet at the annual Wardlow Gingerbread Festival that I am related to Hasland-born William Edwin Harvey, co-founder of the Derbyshire Miners' Association and the first coal-mining Member of

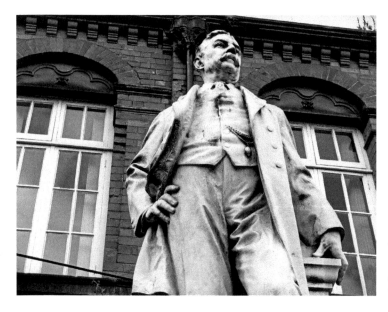

William Edwin Harvey MP, a distant relation of the author.

Costumed characters march through town during Medieval Fun Day 2017.

Parliament for North East Derbyshire, who died of pneumonia en route to the House of Commons to take part in a crucial vote. His statue stands outside the former NUM offices on Saltergate, along with fellow mining MP James Haslam.

So I know Chesterfield well, having visited most weeks growing up. A trip to both the town's library (the eleventh most visited public library in the country according to 2013 statistics) and its Thursday flea market were, and remain, great treats for me.

Chesterfield received its market charter in 1204, and wandering through its streets (particularly the Shambles area, Market Place and Low Pavement), the sense of the history of the place is palpable. Chesterfield's importance as a medieval trading centre is celebrated annually at the Medieval Market and Fun Day.

Of course, the townscape is dominated by the wonky landmark that is the Crooked Spire, or the Church of St Mary and All Saints, to give it its Sunday name. A variety of colourful theories exist as to how the spire acquired its kink, the most prosaic being that at the time of its construction in the fourteenth century skilled labourers were in short supply following repeated outbreaks of the Black Death in the area. The symbol of the iconic spire has been fully embraced by the Borough Council, appearing on their letterheads and street signs, as well as having been used as branding for products

manufactured in the town ranging from tea to pickled onions to cigarettes – I am not aware of any other town in England that celebrates shoddy building work in this manner.

The spire provides a dominant landmark poking up for miles around on the approach to Chesterfield from most directions, and for this foray into Chesterfield's secret past I have thrown my area of focus a little wider over the surrounding communities of North East Derbyshire, taking brief detours to the nearby towns of Dronfield and Bolsover as well. While holidaymakers and day trippers swarm to the nearby Peak District to the west of the town, within a 10-mile radius of Chesterfield many lesser-known gems of villages and hamlets, such as Ault Hucknall, Heath and Oxcroft can be found, located in picturesque and peaceful rural settings, and each with their own unique stories.

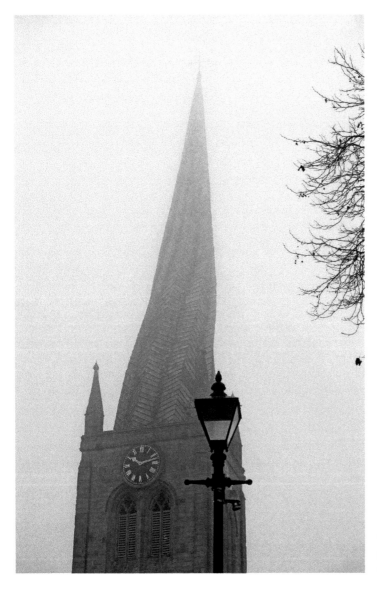

The Crooked Spire, Chesterfield's wonky landmark.

1. Destination Chesterfield!

Chesterfield is a hard-working, practical and down-to-earth sort of town. If we're being brutally honest, it isn't jostling for space with Mallorca, Kos, Biarritz or even Blackpool in peoples' ultimate top-ten holiday destination lists. And yet over the years, the burghers, aldermen and councillors of Chesterfield have done their best to lure people to the town, to enjoy the surroundings, and hopefully spend their money there.

As the variety and scale of industry carried out in Chesterfield has shrunk, in recent years tourism has begun to play an increasingly important part in the local economy. A new specially built octagonal Tourist Information Centre was opened in 2002 in the crooked shadow of the Spire, to replace the previous incarnation housed in the Peacock Centre, a sixteenth-century oak timbered building on Low Pavement whose historic exterior was only accidentally revealed following a fire.

The development of the railways meant people suddenly became much more mobile. Chesterfield became part of the rail network in 1840, after pioneer George Stephenson

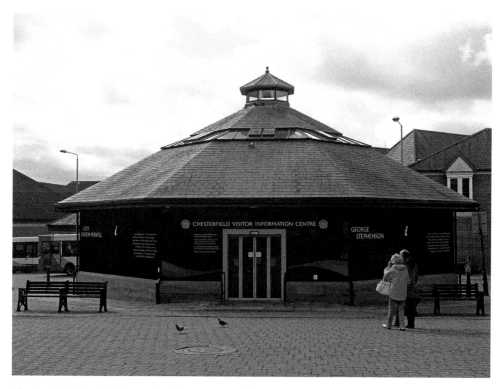

Chesterfield Tourist Information Centre, opened in 2002.

(who was to settle in the area) personally walked most of the way between Derby and Leeds accompanied by his secretary Charles Binns in order to establish a suitable route. The book *An Illustrated Guide to Chesterfield and Its Surroundings* was an attempt on behalf of the Midland Railway in 1899 to sell the town as a desirable destination to visit by rail. With characteristic Chesterfield humbleness, six paragraphs in the writers are reduced to talking about the state of the town's paving slabs (described as 'exceptionally good') and sewers. The guide devotes a lot of space emphasising places that Chesterfield is close to (Chatsworth House, Haddon Hall, the Peak District, Bakewell, Matlock) rather than the charms of the town itself.

Chesterfield's main public space, Queen's Park, was inaugurated at the instigation of Alderman T. P. Wood, a wine and spirit merchant who also served on the Town Council and produced an annual almanac of information about the town and surrounding area. The park was laid out to commemorate Queen Victoria's Golden Jubilee, and in 1887 a large procession made its way to the site where a tree was planted to mark the event. The park was not formally opened until 1893, a superb amenity for the townsfolk consisting of public green space, bandstand, boating lake, cricket ground, children's playground, cycle track, glasshouses, and, latterly, a leisure centre, which has recently migrated a little further up the hill.

Anyone who visited Chesterfield as a result of receiving a particular Edwardian postcard, No. 20088 issued by Salisbury Ball of Sheffield, may have found themselves feeling sold a little short. The card is a multiview consisting of two perspectives of the Crooked Spire and one of the Market Hall. But it's the panorama along the bottom, a 'General View' showing the town as viewed from the Queen's Park's boating lake, which is the most bizarre. Here the colourist seems to have got a little carried away in hand-tinting the original black-and-white photo, and has somehow turned Chesterfield into some sort of Italian resort along the lines of Lake Garda! For what it's worth, 'Dennis', the sender of the copy of the postcard that has ended up in my collection, enjoyed his stay in August 1908, writing to the recipients, Mr and Mrs A. H. Bayliss of Redditch, that he was 'Having a fine time at Chesterfield today Thursday', and that he was off to Matlock the following day.

Chesterfield has a number of other smaller parks, including Stand Road Park, Inkerman Park, Highfield Park and Tapton Park. One public space lost to the mists of time, however, is the Alpine Gardens, which were located by the Crooked Spire. The gardens were a public space gifted to the townsfolk by Alderman Wood in 1908. They were short-lived however, progress putting paid to this glorified rockery. The increase in traffic in the town meant that a road-widening scheme creating a through route from Burlington Street to Church Lane in the 1930s was necessary, leading to its demise.

Black Friday is a recent and rather distasteful American import where consumers are swizzed into buying discounted products they do not need while being incited into a frenzy, leading to ugly scenes like those from 2014 where police across the land had to step in to break up fist-fights between crazed bargain hunters. However, before Black Friday was a gleam in Uncle Sam's eye, the powers that be of Chesterfield had concocted a not dissimilar scheme to get local consumers in to the shops of Chesterfield spending their hard-earned cash.

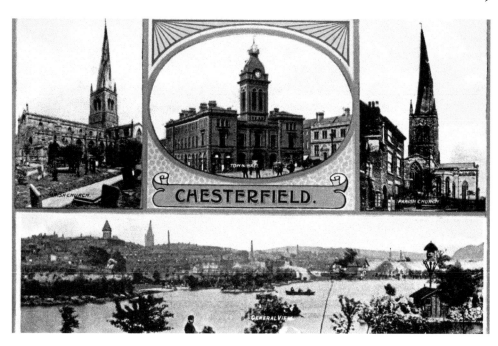

Above: An Edwardian postcard of 'Lake Chesterfield'. (Salisbury Ball No. 20088)

Right: Postcard of the Crooked Spire showing Alpine Gardens in foreground.

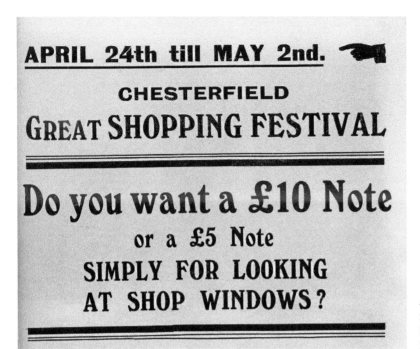

An offer you can't refuse: Chesterfield Shopping Festival, 1914.

In October 1910 the town's first Shopping Festival was staged to promote the delights of shopping locally. There was a window-dressing competition, and a Corporation tram was specially illuminated with 2,000 electric lightbulbs.

In 1914 the Shopping Festival returned, and the public were asked, 'Do You Want a £10 Note or a £5 Note SIMPLY FOR LOOKING AT SHOP WINDOWS?' It was down to the townsfolk to judge which shop they thought had the best-dressed window, with cash prizes for the entrants selected. If all this going round looking in shop windows wasn't excitement enough for the people of Chesterfield, a new feature for 1914 was the engagement of Mr. B. C. 'Happy' Hucks, 'the famous 'upside down airman' for the duration of the festival to perform some stunt flights, an attraction in which the souvenir programme declared (with a degree of self-justification) 'the whole County may reasonably be expected to take a special interest'.[1]

There was another festival in 1923, with live cooking demonstrations on the latest gas appliances at the Market Hall. The fourth and final Chesterfield Shopping Festival took place between 30 September and 7 October 1950, when the country was still finding its feet in the aftermath of the Second World War. The programme's introduction by the mayor, Alderman W. Porter, acknowledged, 'The past ten years have not been easy for either shopkeeper or customer, and we realised more than ever before how much we were indebted to our shops for our daily needs and comforts'.[2]

1 *Chesterfield Shopping Festival*, 1914 programme, p. 71
2 *Chesterfield Shopping Festival*, 1950 programme, p. 1

DID YOU KNOW?

Ostrich-straddling comedian Bernie Clifton, who lives on a farm at Barlow, formerly ran a joke shop in Chesterfield as a sideline. Clifton failed to see the funny side in 2016 when an administrative mix-up saw the printed tracklisting to a CD he had recorded accidentally swapped with songs by death metal group Abhorrent Decimation (whose song titles included 'Eternal Repulsion' and 'Glaciate the Servants'). The *Derbyshire Times* reported him as being 'fuming and furious' at the error, apparently caused by the two CDs having similar catalogue numbers.

Each programme for the 1950 Festival had an individual lucky number on the front cover, and its purchase entered you into a draw to win an HMV television set housed in a smart walnut cabinet and boasting a 9-inch by 7-inch screen. Other attractions included three fashion parades and a Grand Shopping Festival Celebration Dance, all held at the Victoria Ballroom.

Bemoaning the current state of the shops and market in Chesterfield in the early twenty-first century was a constant lament from the townsfolk while I was compiling this book. Every other post on the 'Old Chesterfield Pics' Facebook group seems to provoke the response that the shops and market 'are rubbish compared to how they used to be' and that 'the Council need to pull their finger out and do something about it.' Perhaps Chesterfield is ready for a fifth Shopping Festival to appease these dissenters?

In the 1950s, a magazine called *In Town* briefly emerged, subtitled 'Chesterfield's Monthly Entertainment and Shopping Review'. The magazine attempted to inject a slice of glamour into the weekly business of visiting the Market Hall to stock up on corned beef and powdered eggs. It profiled Hollywood film stars, listed the films running that month at the town's cinemas, and ran pieces on the latest swimwear. A photo competition, 'Is This You?', was an exciting feature where unsuspecting shoppers were secretly snapped buying their wares at the market – a drawn-on arrow pointed to one of them, and if you recognised yourself as the chosen one then you applied to the editor and would be rewarded by a voucher for one guinea to be spent at a list of selected market stalls. I'm sure the woman photographed shopping with rollers in her hair was thrilled to find herself the lucky winner.

DID YOU KNOW?

Chesterfield received its market charter in the year 1204 with the market originally sited by the Crooked Spire; however, it quickly proved so successful that by the 1220s it had outgrown this space and was moved to its present location instead. The charter states that the market cannot be closed down unless a week elapses with nobody buying anything from it. So if you want to ensure it continues, keep shopping there!

Chesterfield became an enforced holiday destination for its own townsfolk and those from neighbouring areas during the 'Holidays at Home' scheme of the Second World War. Wartime restrictions greatly curtailed people's freedom of movement, but in spite of the mood of national emergency, Chesterfield was determined that its residents could still be able to enjoy themselves, and a packed programme of events was put together between July and September 1944. There were numerous dances, a gymkhana, Cumberland and Westmoreland wrestling, amateur dramatics performances, an exhibition by the Chesterfield Photographic Society, cycle tours out of town into the surrounding countryside, bowls and cricket competitions, swimming galas, a horticultural show, a rabbit show and band concerts in Stand Road, Eastwood, Brearley and Queen's Parks. A taste of the seaside was brought inland with donkey rides in Queen's Park and a Butlin's funfair set up at Whittington Moor. Following the Country Day and Gymkhana, which brought huge crowds into the town, the *Derbyshire Times* reported, rather unsympathetically, 'One always expects some lost children in a crowd of nearly 50,000, but they really were a pest to the officials on Saturday. The Chief Constable (Mr. L. Milner) told me that they had 83 in the course of the day, and looking after them presented quite a problem. They were all sorted out and returned to their parents. Quite a lot of children were also fished out of the park lake, and they were wrapped up in blankets at the ambulance station whilst their clothes dried.'[3]

The most bizarre element of the festivities was the hanging of iodine diffusers in the trees of Queen's Park. This scheme was at the instigation of Dr Goodfellow, who was worried about the prevalence of 'Derbyshire Neck' or goitre, caused by an iodine deficiency. Dr Goodfellow claimed that as a result of the dispensers, there was more iodine in Queen's Park than on Blackpool Beach (a previous scheme of Goodfellow's for warding off goitre in the locality was encouraging the wearing of pottery lockets made by Oldfields round the neck that contained iodine tablets).

'YES!! There really was an ... ASHOVER ZOO.' So states a display inside a former telephone box converted into a snug, unstaffed tourist information centre for the village. The unlikely tourist attraction in this ruggedly beautiful corner of Derbyshire went by the rather flowery name of 'Pan's Garden'. The brainchild of Clinton and Jill Keeling, it opened in the grounds of Jill's family home in 1955. One of their sons, Jeremy, was to go on to co-found the Monkey World primate rescue centre in Dorset. Jeremy remembers with forthrightness his perspective of growing up at the zoo in his autobiography *Jeremy & Amy*, criticising the makeshift conditions and dysfunctional environment. It did not help matters that the resident monkeys and parrots learnt how to pick the pockets of the visitors, with the creatures managing to liberate people's false teeth and wedding rings. Pan's Garden closed down in 1972.

3 *Derbyshire Times,* Friday 11 August 1944, p. 1

2. The Centre of Industrial England

Chesterfield once promoted itself as the 'Centre of Industrial England'. I discovered this Chesterfield postmark (below) used in the late 1960s on an envelope containing my grandad's 1969 Income Tax returns among his effects. When I posted it on the 'Old Chesterfield Pics' Facebook group, Brenda Moseley remembered in reply, 'There used to be a road sign at the bottom of Hillcrest Road/Mansfield Road saying "Welcome to Chesterfield the Centre of Industrial England"', remarking that it was 'A sad day when that was removed'. This post evoked a bittersweet nostalgia among townspeople, with several able to remember specific locations of similar signs at various points of entry to the town, and many remarking on the much-diminished level of industry compared to the heyday when the signs were up. Reading the aforementioned *Illustrated Guide to Chesterfield & its Surroundings* of 1899 leaves you with the impression that Chesterfield at that stage was virtually self-sufficient, with everything from carpets to cigarettes to cannon balls being made in and around the town.

Now former collieries have been redeveloped as country parks, and town centre factory sites given over to leisure and shopping use. The former industrial titans of Bryan Donkin, Markham & Co., and the Staveley Coal and Iron Co., which between them employed huge quantities of local people, are all now no more. Robinsons, a company famed for its philanthropic attitude towards its employees, continues operations in the town, but in diminished form.

The outcome of the 2016 Referendum regarding Britain's membership of the EU was interpreted by cultural commentators as a rejection of globalisation, a motive which is

'Chesterfield for Industry and Countryside' – 1960s postmark.

perhaps reflected in the figures of 60 per cent of those who voted from Chesterfield, 63 per cent from the North East Derbyshire constituency, and 71 per cent of Bolsover voters casting their votes towards Leave. Having seen a large amount of the manufacturing industry that was once concentrated in the area disappear overseas is likely to have influenced how at least some locals cast their votes.

However, it was not always thus. One now-vanished industry that developed in Chesterfield was actually introduced by our continental neighbours. Following the Napoleonic Wars of the early nineteenth century, Chesterfield was deemed a suitable location to harbour around 200 French prisoners of war, given that it was located one of the furthest distances inland from either the east or the west coast and therefore would be harder for invading French to turn up to liberate their countrymen. The prisoners brought with them a new industry: glove-making.

Hall (1839) described the process: 'The gloves are netted with one needle, (here called pegging) and expeditiously made, - neat in appearance, and durable in the wear ... the great demand there has since been for them, has given employment to numerous hands, and been of great benefit to the town.'[4] The glove-making industry carried on in the area after the prisoners had departed, although some ended up marrying local women and staying.

The gloves were not the only fashion items to have been manufactured in the area. The quiet hamlet of Stainsby near Hardwick Hall previously had an alehouse (located in a now-demolished cottage) going by the name 'The Hatter's Block'. This name reflected an obscure and long since-vanished local trade, the making of top hats, which were dyed purple with damsons grown in the area. Before it became synonymous with coal mining, Bolsover enjoyed a brief flourish as the centre of a buckle-making industry, producing durable yet highly polished iron buckles for shoes.

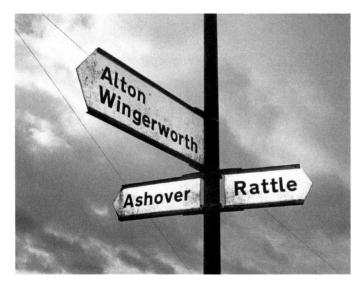

Rattle: a formerly noisy corner of Ashover.

4 Hall (1839), pp. 18–19

Surviving former
weavers' cottages
at Rattle.

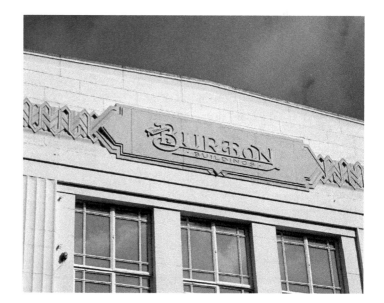

Burton Buildings,
Burlington Street.

A now-peaceful corner of Ashover has the unusual name 'Rattle', a hangover from
a cottage industry that thrived here in the eighteenth and nineteenth centuries. In a
precursor to modern-day 'sweat shops', here a local entrepreneur bought material and
paid the cottagers a piecemeal rate to turn it into clothing using mechanised stocking
frames installed in their attics, returning to collect the finished articles (and the majority
of the subsequent profit). When all the weavers were in full flow, the combined noise of
the rattletrap apparatus was very noisy – leading to the name, which has outlived the
industry. Most of the former weaver's cottages have now been demolished, but a few
survive at the junction of Chapel Hill and Hill Road.

A more recent contribution from Chesterfield towards the world of men's fashion is the Burton Menswear chain. Burton began life in 1904 as The Cross-Tailoring Company established by Montague Burton, initially operating from No. 20 Holywell Street. Born Meshe David Osinsky, the self-retitled Burton fled his home country of Lithuania in 1900 to escape Russian persecution. The chain closed its Chesterfield branch in 2016, and the Burton Buildings on Burlington Street (try saying that ten times fast out loud) is at the time of writing a Greggs' pasty emporium.

While Stoke-on-Trent is famed as the pottery capital of the UK, Chesterfield once had its own thriving pottery industry, centred around Brampton and Old Whittington, specialising in stoneware and brown earthenware, utilising the naturally occurring clay of the area. A feature on the Barker Pottery Co. in the *Illustrated Guide* of 1899 gave an idea of their output: 'baker's, or loaf pots, coffee pots and coffee jugs, fountains, jars and moulds, spittoons, tea pots, and brown bottles in best and second qualities'.[5] My dad remembers scrounging rejects from Pearsons Potteries for the plate-smashing stall at the annual Coalite Sports Day. The now-vanished industry is remembered in the street names Pottery Lane (East and West) and Potter's Close at Whittington. Closer to the town centre, Foljambe Road was formerly called 'Pothouse Lane'.

Whittington was also once a centre of glass production, operations dating back to the early 1700s when Richard Dixon built a furnace for producing glass on a site that became known as Glasshouse Common. Much of its output was sent to nearby Sheffield where it was bought by the Sheffield plate manufacturers to incorporate into their high-quality tableware. Table glass, drinking glasses, window glass, plain, crown and coloured glass were all made at Dixon's enterprise.

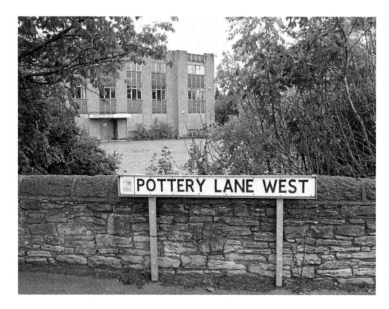

Reminder of a past industry: Pottery Lane West, Whittington Moor.

5 Midland Railway Co. (1988), p. 35

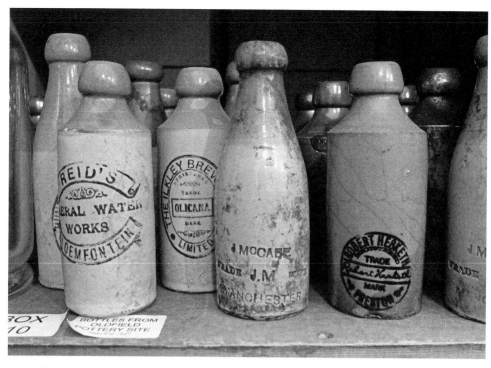

Examples of Chesterfield pottery in the Museum Store. (With kind permission of Chesterfield Museum Service, Chesterfield Borough Council)

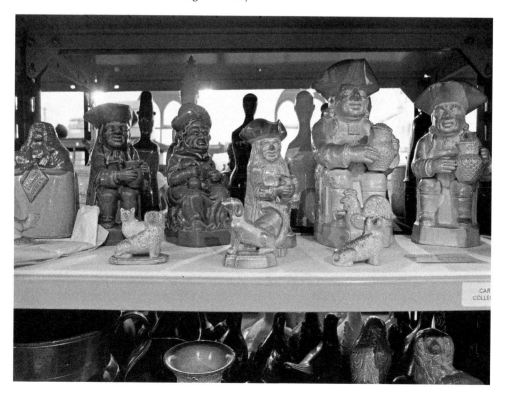

Vices were well catered for, with a number of large breweries once operating in the town (several craft breweries have filled the gap left in their wake in recent years such as Townes Brewery, Brampton Brewery and Spire Brewing Co.). The large Mason's factory at Spital produced cigarettes, in its day one of the largest employers of women in the area. They manufactured a range called 'Spire', with a picture of the crooked church adorning the packet. The 'Chesterfield' brand of cigarettes, however, have nothing to do with the town in North East Derbyshire – these are named after Chesterfield County, Virginia, USA. This area was itself named after Philip Stanhope, 4th Earl of Chesterfield and former British Secretary of State, a man who, beyond his title, had little to do with the town. How Chesterfield sofas got their name is more of a mystery – there is a rather vague theory that Stanhope may have first commissioned the design. The Chesterfield coat, a long tailored overcoat with a collar usually made of velvet, again is a red herring. The style first emerged in the 1840s and was named after a later Earl (the 6th), George Stanhope, something of a fashion leader in his day.

Chesterfield's geology is in a large part to thank for the industrial productivity of the area. Until the closing of Markham Pit in 1994, coal mining was synonymous with North East Derbyshire, however coal was not the only natural resource that was extracted locally. While lead mining is much more readily associated with the White Peak area of Derbyshire, at Ashover the presence of Carboniferous limestone among the millstone grit provided the right conditions for the formation of lead ore, which was successfully mined here for many years. At nearby Stone Edge, a bleak spot high on the moors above Chesterfield, what has been claimed as the oldest industrial chimney in England can be found. The pool near the chimney was formerly used to power the bellows. These are the only remains of what was once a large-scale operation owned and run by the London Lead Co., who worked the site for around 100 years. The location of the chimney, Belland Lane, is a reflection of the former industry carried out here – belland being a dialect word for waste byproducts from smelting lead, which seep into the ground and can consequently poison animals and plants.

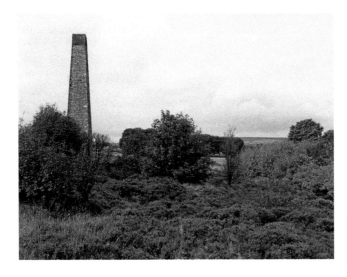

Stone Edge, the oldest industrial chimney in England?

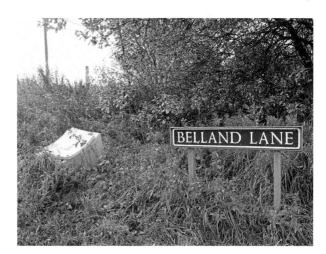

Belland Lane, with the chimney just visible in left background.

Lead was worked in Derbyshire as far back as Roman times; Roman 'pigs' of lead have been found in the Matlock area stamped 'Lutudarum'. Lutudarum is thought to be an administrative Roman trading centre for lead and many experts believe it to have been located at Chesterfield. However, there are several alternative theories with Carsington, Wirksworth and Crich all being suggested as rivals.

DID YOU KNOW?
Some of the French prisoners of war were detained in the cellar of the Golden Fleece pub on High Street. They were free to roam the town as they pleased until 8 p.m. when a curfew bell known as 'The Frenchman's Bell' was rung from the Spire.

There was also the Great Derbyshire Oil Rush of the early twentieth century, which proved something of an anticlimax. During the First World War, Britain's reliance on other countries for importing oil became a growing source for concern, so the government allocated a budget of £1 million for trying to develop a homegrown oil industry.

Given that this was an entirely new venture for Blighty, the equipment needed to prospect satisfactorily for oil wasn't obtainable in this country. The Americans, who by the early years of the twentieth century were a dab hand at this kind of thing, possessed the necessary tools. However, there was a problem given that America, who at the time had not yet entered the conflict, had declared oil drilling equipment 'strategic material', meaning that it could no longer be purchased by foreigners. The way around this snag was to bring over an American workforce along with their tools to conduct the oil explorations. How well these Americans could understand the Derbyshire accent when they arrived I would love to know, but this is something that sadly does not seem to be documented.

In addition to various sites in Derbyshire, North Staffordshire and Scotland were also deemed suitable for probing, but it was on the Hardstoft estate near Tibshelf that UK oil was first struck in 1919. I visited this historic site, now an unassuming and windswept spot at the rear of a garden centre, and was shown the remains of the oil well – although there is not now much to look at – by the Oilwell Nursery's owner, Philip Schofield (no, not THAT Phillip Schofield). 'I get people coming from all over to visit, I've had the Professor of Earth Sciences at the University of Miami, a student from Princeton University ... Durham University come to see me quite a lot', he told me.

'So why did they drill here?' I asked Mr Schofield. 'Well this is it – no one really knows – but we're on an anticline, and you do often tend to get oil on an anticline.' Additionally, seepage of oil underground had anecdotally been reported by both coal and lead miners across Derbyshire over the years. Natural gas was discovered at another site nearby during subsequent oil drilling operations, which was piped to supply Pilsley Colliery.

Elsewhere, oil was also drilled for on Brimington Common, on the site of the local recreation ground. The prospectors here erected a vast storage tank in readiness, but their ambitions outstripped the actual supply, which was disappointingly minimal. The borehole reached a depth of 4,040 feet and then tapped water having a temperature of 120 degrees.

Not much to look at – Britain's first oil well.

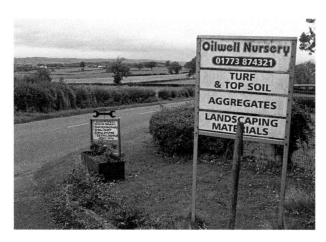

Oilwell Nursery, an unassuming historic spot.

3. Façades

In and around Chesterfield, all is not sometimes what it at first appears.

Take for example the black-and-white timbered buildings on Knifesmithgate. Chesterfield clearly has a strong medieval pedigree (celebrated at the annual Medieval Fun Day), with its thirteenth-century church, market held since 1204 and evocative Shambles area containing the Royal Oak Inn – town centre base of the mysterious Knights Templar, whose stronghold was at nearby Temple Normanton. The Knifesmithgate buildings, while appearing ancient, only date to the 1920s, however. Thompson and Lilley (1989) report an anecdote that the Knifesmithgate buildings are the result of a visit to Chester by an official from Chesterfield Corporation, who took a fancy to what he saw there and decided to replicate it on the streets of Chesterfield. Eminent architectural critic Nikolaus Pevsner was not convinced by the results, terming it 'Chesterization'. The columns on the buildings are adorned with a series of interesting wood carvings, at times grotesque, almost gargoyle like, produced by Frank Tory & Sons of Sheffield.

In a common dilemma that faced many towns throughout the land, in the 1960s Chesterfield's powers that be had begun to conclude that with an increase in car ownership and changing shopping habits, the town as a centre for shopping had become out of date, with shoppers defecting to Sheffield and Mansfield instead, leading to local economic decline. A drastic solution was deemed necessary, and it arrived in the shape of 'The Allen Plan', a design drawn up by Newcastle-based architect J. S. Allen, which met with the enthusiastic approval of the council.

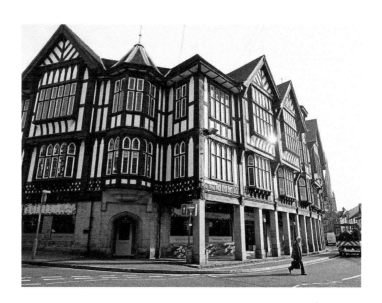

'Chesterization': Knifesmithgate.

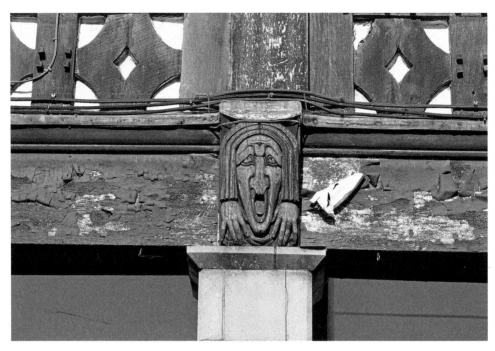

Detail of a woodcarving by Frank Tory & Sons, Knifesmithgate.

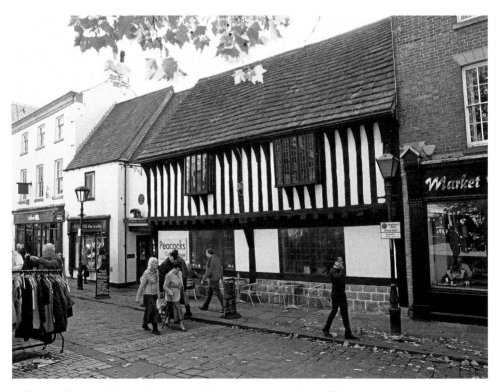

A Phoenix from the flames: The Peacock Centre, now Peacocks Coffee Lounge.

The groovy 1960s modernising broom of Allen proposed to sweep away the Market Place, Market Hall, New Square, the Shambles, and most of Low Pavement. 'I'm a fan of modernist architecture, but this probably would have been a disaster given its scale and impact on the historic centre of Chesterfield,' Chesterfield Borough Council's Planning and Conservation Officer Scott Nicholas told me (it would also have robbed him of a lot of things to conserve).

A sea change in attitude came as a result of an accidental 1974 fire at the Peacock Inn (now Peacocks Coffee Lounge), which burnt away the art deco frontage added upon its conversion to a pub in 1929. It became obvious that the building was of much greater historicity than was previously thought.

Following the fire, people began to look closer at the Peacock's neighbouring buildings on Low Pavement and the Market Square, which were still under threat. While individually none of the buildings were particularly astounding, put together the realisation dawned in the nick of time that they were of sufficient 'townscape merit' to warrant keeping. The problem of how to retain the look and feel of Chesterfield's historic townscape, while also providing modern shopping facilities for the town was solved by retaining the shop frontages but demolishing the backs of the properties, and carefully knitting up the remaining façades with a newly built shopping centre behind. The saga having dragged on for most of the 1960s and '70s, finally ended when the Pavements Centre opened in 1981.

A sadder façade, which overlooks the M1 motorway, is that of the once-grand Sutton Scarsdale Hall. A hall of some form had existed here since the 1460s. In 1724, Nicholas Leke, 4th Earl of Scarsdale, commissioned Francis Smith to build him a grand statement property to rival Chatsworth – bringing himself to the brink of financial ruin in the process. Particular attention was lavished on the interiors. The hall later passed through sale to the Arkwright family, descendants of Richard Arkwright of Cromford Mill fame. William Arkwright auctioned off the estate in 1919, and the hall was asset-stripped, being left without a roof and open to the elements.

The story goes that some of the hall's interiors went on subsequent bizarre globetrotting journeys. Panelling from one room is said to have been bought by newspaper magnate William Randolph Hearst, who then sold it on to Paramount Studios where it was used as set dressing for the 1945 Hollywood period melodrama *Kitty*. The interiors of another room are meant to have been sold to the Philadelphia Museum of Art and put on display there.

However, having been in correspondence with Donna Corbin at the museum, it seems this is not quite the full story. Some years ago, Corbin worked with Dr Andor Gomme, author of a book on Francis Smith, to establish that only a fraction of the panelling at the museum actually originated from Sutton Scarsdale. The museum bought their room off Robersons of Knightsbridge, an auctioneers known to be a little 'creative with the truth' when describing the provenance of their lots. Corbin got in touch with the Huntington Library in Pasadena, California, who had acquired the Hollywood panelling as used in *Kitty*. They told her they do not believe their panelling is eighteenth century (and thus not from Sutton Scarsdale), and much of it has now been put in storage there.

While I hate to debunk a good and widely accepted story, this does all beg the question: where did Sutton Scarsdale's interiors really end up?

The shell of the hall was purchased by Osbert Sitwell of Renishaw Hall on the day it was due to be pulled down. He subsequently donated it to the nation as a memorial to man's folly.

The old meets the new: Low Pavement and Pavements Shopping Centre.

How 'Low' Pavement got its name.

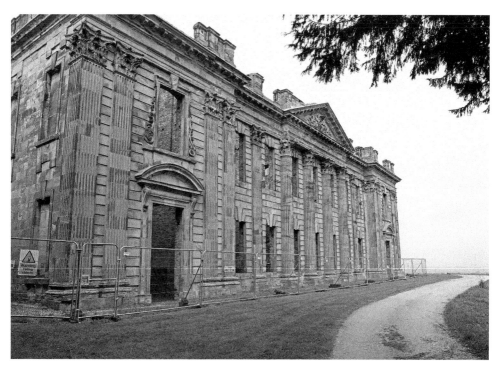

Evidence of man's folly: Sutton Scarsdale.

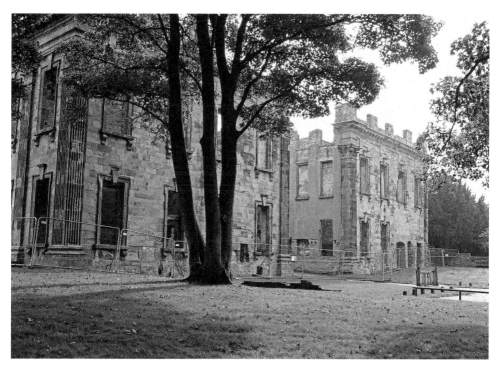

The ruins of Sutton Scarsdale.

4. Customs, Folklore and Legends

Derbyshire is one of the richest counties in the UK in terms of its folklore, calendar customs, legends, superstitions and folk beliefs. In the Peak District their survival has been ascribed to the remoteness of the self-contained hill villages prior to advancements in road and rail travel. But even in a practical, industrial town like Chesterfield and the surrounding communities, strange rituals and beliefs prevail.

On the surface, coal miners might have appeared a tough and unsentimental breed, but when you consider the everyday dangers that they faced as part of their job, leaving nothing to chance seems entirely understandable. Addy (1895) reports that, 'Colliers in the North of Derbyshire leave a hundredweight of coal in the pit every week for the fairies.'[6] It was thought bad luck for a son to work in the same pit district as his father, and if a collier reached the mine and realised he had forgotten to bring something (i.e. his 'snap' tin), it was considered extremely unlucky to return to fetch it. It was also bad luck to work down the pit on New Year's Day.

In a less enlightened age when fewer things could be rationally explained by science, superstition existed at all levels of society. Bolsover Castle, built on the site of an earlier medieval castle in the early seventeenth century for William Cavendish, 1st Duke of Newcastle, contains several strange markings etched on the wall by the fireplace in the Star Chamber. These are apotropaic marks, also known as witches' marks, and were scratched into the fabric of buildings to prevent evil spirits from entering. They are quite difficult to find (we asked a guide for help locating them) and show up better when a light is shone on them.

The people of Chesterfield were once menaced by a dragon according to two versions of a folktale collected by Ruth Tongue. In the first, the dragon was defeated by a priest climbing 'Winlatter Rock' in the surrounding countryside and assuming the shape of a cross as the dragon flew over. This took so much willpower that his feet sunk into the rock. In version two the moral seems to be the value of teamwork. 'Three Valiant Lads', all brothers, commission a blacksmith to make a huge sword, which they carry up to Winlatter Rock. Being repeatedly told of the impossibility of this task, their reply is that 'One can't but three can'. When the dragon approaches, at a signal the church bells of Chesterfield and Grindleford were rung and the giant sword brandished at it. It was consequently so disorientated, it disappeared off into a Blue John Mine, never to be seen again. I have not managed to locate Winlatter Rock on any maps.

At Handley near Staveley is a Jacobean house called the Hagge, built in 1630 by Sir Peter Frecheville. In the grounds of the house an oak tree formerly stood that was said to have

6 Addy (1895), p. 141

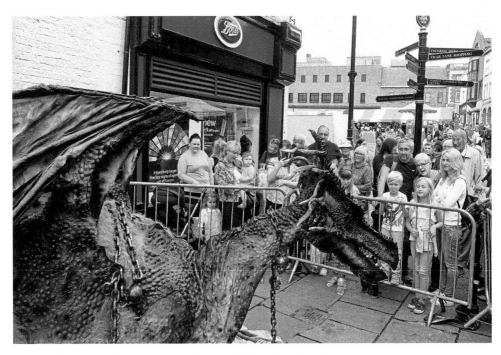

The Winlatter Rock dragon returns? Chesterfield Medieval Fun Day, 2017.

sinister powers. It was known as 'The Mandrake Tree' (after the plant which was said to resemble the human form and possess magical properties). If its branches were cut it was supposed to have let out a human-sounding shriek and to ooze a thick red liquid resembling human blood. The tree perished by natural causes, being blown down in a gale in 1883. Court (1946) further garnishes the tale, saying that the tree was meant to be protected by a 'vicious and dangerous ogre',[7] and was alleged to be the site of Druidical ceremonies.

Addy (1895) recorded the presence of a 'cock-crowing' stone at Ashover that was said to turn around whenever it heard a cockerel crow. In addition a nearby rock known as the Fabrick (also spelt Faybrick or Fabric), a prominent local beauty spot, was said to possess wish-granting properties. The method is to sit upon it while making your wish three times.

As in most communities worldwide, to ensure the successful turning of the seasons as well as marking the passing of time a complex series of rituals or 'calendar customs' are followed in and around Chesterfield. In common with much of the North of England and Scotland, first-footing was (and in some households, despite the scarcity of coal fires in the twenty-first century, hopefully still is) practiced at New Year in the Chesterfield area. The first person to cross the threshold after the stroke of midnight should ideally be a tall dark-haired male to ensure luck for the forthcoming year, and he should bring a new piece of coal to put on the fireplace.

7 Court (1946), p. 23

Before the Industrial Revolution when life was much more tied in with the growing of crops and the rhythms of the seasons, the Christmas break lasted until Plough Monday, the first Monday after Epiphany (6 January) – twenty-first century retail workers who have to be at their stations at 4 a.m. on Boxing Day to prepare for the 'January' sales may be reading this and wishing they were born an eighteenth-century agricultural labourer. Even then, 'work' resumed in a boisterous fashion with the Plough Monday celebrations, where farm workers toured the district dressed in fantastic costume, usually performing a short mummer's play or songs with musical accompaniment from bladder fiddle and dancing. Completing the tableaux was an old-fashioned horse-drawn plough the team towed around behind them, exhorting money from householders with the threat of ploughing up their doorsteps if they didn't pay up. The *Derbyshire Courier* of 13 January 1849 gave an account of these rustic rabble coming into the town centre from the surrounding country district:

> On Monday last, being Plough Monday, a number of agricultural labourers from, as we are informed, the neighbourhood of Ashover, paraded the streets of Chesterfield, harnessed to a plough, which was steered by a rustic encased in bands of straw. Their attire was of a motley description, but the procession was destitute of a redeeming feature which was attached to it in days of yore – that of music: the chief object, of course, was the collecting of 'plough money'.[8]

Another January event is wassailing, a traditional English custom whereby apple trees are ritually toasted, performed to ensure a healthy apple crop later in the forthcoming year. Every January since 2012 an annual wassail event has been held at Inkerman Park, tucked away behind a row of cottages off Ashgate Road. It has only comparatively recently – since the 1970s – been a public space. In the early years of the twentieth century it was the location of a busy jumble of various manufacturing industries including a coal mine, clay pit, quarry, pottery and brickworks with its own light railway. This brickworks was called 'Wasp Nest', and although Inkerman Park is its official name, the park itself is now known locally as 'The Wasp's Nest'.

Just inside the park a small gazebo is set up, underneath which a stall is offering hot mulled cider and apple juice and homemade cakes and flapjacks in exchange for donations

8 *Derbyshire Courier*, Saturday 13 January 1849, p. 2

to the park funds. To begin today's proceedings the Cock and Magpie morris dancers perform a series of dances in front of the Inkerman Cottages at the park's entrance. The team get their name from the two birds who bear the town's coat of arms, themselves adopted from the former Cock & Pynot Inn on Whittington Moor (nowadays Revolution House), 'pynot' being a local folk name for a magpie.

After the morris dancing, songsheets are handed out to everyone present. The park contains four fruit (a mixture of apple and plum) trees funded by Transition Chesterfield, planted in late 2010 by the Friends of Inkerman Park with help from pupils of the nearby Old Hall School. An additional ten apple trees were planted in November 2013. The crowd splits off into small groups of four or five and congregates around each tree. First of all a wassailing song is sung to the trees, and then a short ode is communally chanted, with anyone who is wearing a hat doffing it to the trees at the appropriate moment. The traditional climax of a wassail event is firing shotguns into the trees in order to frighten off any evil spirits who might tamper with the apple crop. Inkerman have rather charmingly downsized this gesture to firing party poppers into the branches.

In our electrically lit, central-heated existence where obtaining food involves a drive to the supermarket or corner shop, or a few clicks on a website followed by someone delivering the goods to our door, it is hard to fully appreciate what the return of the summer meant to our ancestors living in a more agrarian age. May Day used to be universally and joyfully celebrated with much feasting, dancing, gathering of flowers, dressing up and all-round lustiness.

The *Derbyshire Courier* of 7 June 1851 reported that, 'The old English custom of dancing round the maypole is still observed and spiritedly celebrated at Palterton, near Bolsover. Last Friday the May pole was decorated with ten elegant garlands, and two booths were erected to take tea in ... When tea was over, the Pleasley band ... attended to the party under

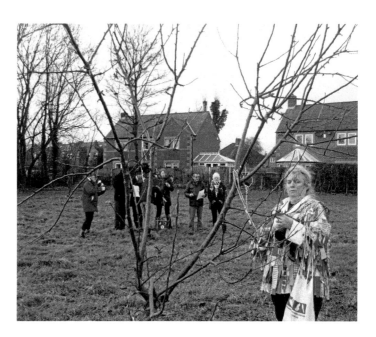

Inkerman Park
Wassail: honouring the
apple trees.

Inkerman Park Wassail: party popper streamers in branches.

the May pole, and dancing was spiritedly kept up for some time. The pole and the weather vane at the top had been painted for the occasion, and every step was taken to give eclat to the joyous festival'.9 From this short report it sounds like the maypole was a permanent fixture of the village, and had been spruced up in readiness for its annual moment. A few centuries further back, an entry in the Manor Court Rolls of the Savage family (the local aristocrats until they sold their manors to Bess of Hardwick, who was expanding her property portfolio with ambitious zeal) records that at a court held at Heath on 29 April 1558, John Hardwyke, Christopher Hardwyke and James Coupe were all fined for the crime of cutting down the maypole – again, suggesting it was a permanent erection.

The *Northern Whig* newspaper reported on a horrific accident that occurred at a May Day fête at Whittington Moor in 1891:

> A deplorable accident occurred to-day at Whittingtonmoor [*sic*], near Chesterfield. A May Day *fête* was being held in a field, at which about five thousand persons were present. On a platform erected near a Maypole about a hundred persons were seated, when the structure suddenly collapsed and fell. A boy of twelve, named Woodward, who had taken refuge beneath the platform, was crushed to death, while about thirty people who had fallen were injured, some seriously. The wounded were removed to Chesterfield Hospital. The injuries of a boy named Wainwright are serious that his recovery is doubtful. While severe, none of the other cases are so serious.10

At Ashover, May Day continues to be celebrated with vigour. The village's annual May Day Carnival was instigated in 1995 and offers a packed day of classic English entertainment. There is maypole dancing, the crowning of a May King and Queen, further dancing

9 *Derbyshire Courier*, Saturday 7 June 1851, p. 3
10 *Northern Whig*, Wednesday 20 May 1891, p. 5

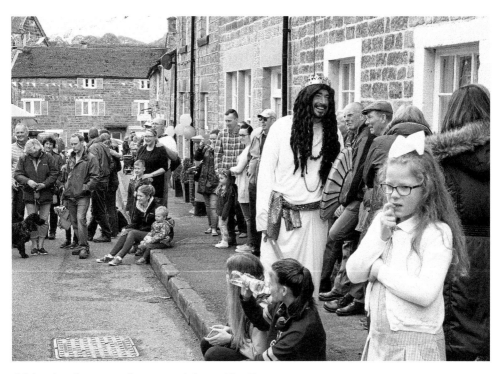

Celebrating the return of summer: Ashover May Day.

Quintessential English fun: Ashover May Day.

from Ripley Morris Men and Chesterfield Garland Dancers, stalls of homemade produce including chutney, jams and whistling walking sticks (all made in Ashover), and Punch and Judy.

The concept of May Day as a public holiday was reinvigorated in 1886 when over 300,000 American workers walked out of their jobs in demand of a day off. The idea of a day celebrating labourers and the working class spread around the world. Chesterfield, Bolsover and North East Derbyshire all have a strong pedigree of left wing politics, having elected both the late Tony Benn and Dennis Skinner to Parliament (although one of the shock results of the 2017 snap election was North East Derbyshire going to the Tories – Labour had held the seat since 1935). Therefore, it is unsurprising that the town marks the day. The May Day gala was first held in 1977 in Stand Road Park, but later transferred to the town centre, where a large parade and march is held around the streets of the town, spearheaded in 2017 by the Ireland Colliery Band. The rally concludes with speeches in New Square.

The second May Bank Holiday Monday falling at the end of the month is Whitsuntide. This was formerly a large church social occasion nationwide where children donned their smartest new outfits for the annual 'Whit Walks'. While these have, by and large, died out, in Chesterfield the holiday is still marked on a large scale, with local churches coming together as they have since 1850 to form another large procession in the streets of the town with decorated floats for the Whit Walk under the name of Annual Procession of Witness.

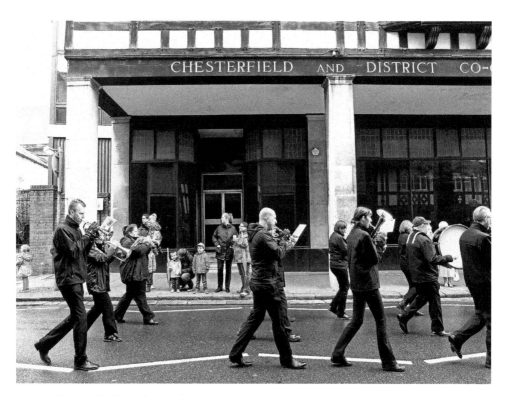

Leading the march: the Ireland Colliery Band at Chesterfield May Day rally.

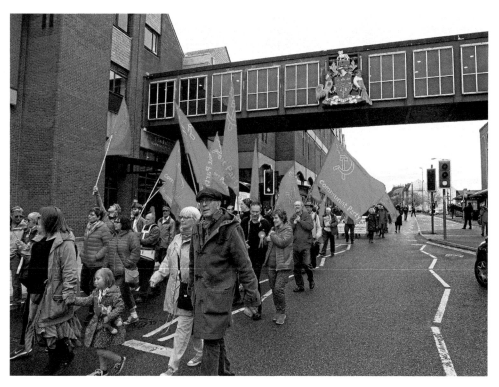

Painting the town red: Chesterfield May Day rally.

Derbyshire's most famous custom of well dressing takes place throughout the summer months, where elaborate pictures are produced through intricately arranging flower petals and other natural materials into a design in a wooden board filled with clay, in thanks for the gift of water. While more popularly associated with the villages of the White Peak, a healthy number of well dressings appear in Chesterfield and surrounding areas (*see* the 'Water' chapter). The erection of Chesterfield's dressings in early September marks the close of the well dressing season for another year.

Rushbearing is a once-widespread custom still upheld in some places such as Saddleworth and Peak Forest near Macclesfield where the annual renewal of the cut rushes formerly used to carpet the stone floor of the church was marked with much celebration and feasting. Local colour was added at Ashover Church by adding bracken and heather cut from the surrounding moorland to the rushes.

Another mysterious old church custom is that of clipping, or clypping, the church. Here, during the culmination of an annual service, the congregation exits the building and forms a giant ring around the exterior, all holding hands in a figurative 'embrace' of the church. It was revived at Wirksworth during the 1920s and still takes place there every September as part of the town's festival. St Bartholomew's Church in Old Whittington clypped their church for a spell in the 1960s. It was introduced here by Revd John K. Rollinson, who had formerly been the vicar at Wirksworth and brought the custom along with him to his new posting.

In the days before GPS, satnavs and the Ordnance Survey, it was once a widespread annual custom for parishes across the land to 'Beat the Bounds', or conduct a yearly perambulation of the parish boundaries as an exercise in drilling into the next generation where the limits lay. Holymoorside marked the millennium by commissioning a series of eight new boundary stones, which were placed at positions along the outskirts of the village, as well as producing a booklet of guided walks around the boundary. The practice of conducting a boundary-beating walk around the stones was revived in 2009 by local councillor Martin Thacker – usually held in late July or early August.

The Wakes began as a patronal festival linked to the specific saints' day for the village church, but gradually became a more secular affair and a much-anticipated release from the usual daily grind. Hardwick Wakes, held at Whitsuntide, was still going in the mid-1960s when my parents were first courting, my dad remembers walking with my mum over the fields from Palterton to attend what he describes as a 'vast' fair in the grounds of Hardwick Hall, with attractions including bearded ladies and 'Have A Go' boxing booths (something which the population of local colliers were all too keen to sign up for, especially after a few drinks). Brampton, Bolsover, Tibshelf, Clay Cross, Ashover, Staveley, Brimington, Barlow, Hasland, Calow, Scarcliffe and Holymoorside all once had their own Wakes.

Dronfield Cycle Parade was an annual event first staged in 1894 at the instigation of the Dronfield and District Cycling Club. Cycles and prams were decorated and elaborate fancy dress donned by the participants, forming a parade led by the Dronfield Town Band

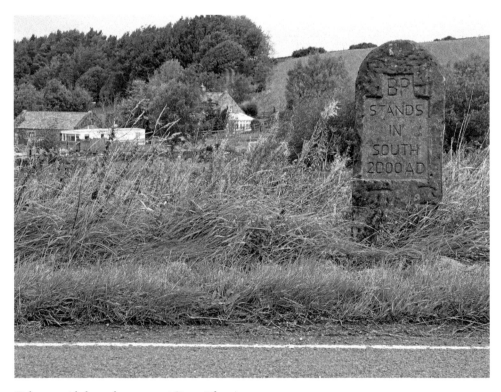

Holymoorside boundary stone at Stone Edge.

Mischief Night was once widely celebrated across the land by children, although the date on which it was observed varied greatly from place to place. At Holmewood, it was marked on 4 November, where the modus operandi included throwing bangers through people's letterboxes, setting light to other people's carefully prepared bonfires a day early, and 'bull-roaring', where a householder's cast-iron drainpipe was stuffed with screwed-up newspaper, which was then set alight; the resultant flames shot up the pipe and produced a roaring noise. This would draw the enraged homeowner outside, to the cheers of the assembled mischievous children.

A widespread European custom throughout the Church in the Middle Ages was the electing of a boy bishop by choosing a junior member from among a church congregation or the choristers who would then officiate over a few weeks' worth of church proceedings – often part of wider pre-Christmas festivities known as the Feast of Fools in which the normally staid Church let its hair down a little. There have been revivals across England since the twentieth century including at Hereford, Westminster and Salisbury Cathedrals. Calow Church of England (V.C.) Primary School also stage an annual boy bishop ceremony, and headmaster Martin Thacker (of Holymoorside boundary-beating fame) kindly let me attend in 2016. Martin wasn't sure how long the custom had been taking place at Calow; it was occurring by the time he took his post in 2004. It had evolved a little over the years: initially the boy bishop was selected by the Church. This then changed to him being selected by the school, but as Martin explained to me, 'We decided to change this because we didn't want to be accused of favouritism'. Now pupils who feel they would like to take on the role put themselves forward for election, having to convince their schoolmates of why they are suited.

One of the biggest changes, which admirably came at the instigation of the school's pupils, was the transition from *boy* bishop to *young* bishop, as the children quite rightly pointed out that as female bishops are now allowed to be ordained in the UK, why should girls not stand for the position of bishop at Calow? The first girl bishop was elected to the role in 2015. However, in 2016, six boys stood forward, but no girls. The successful candidate was Joe Voy, and along with the school's pupils and his parents Martin and Karen, I watched him being officially inaugurated into his role by the country's seventh female bishop, the Venerable Janet McFarlane, the Bishop of Repton, who took office earlier in the year.

In former days in and around the Chesterfield area, around Christmas and New Year what could have been more festive than ganging together with your mates and going out and performing a ritual play about the slaughter of a sheep?

This was the Derby Tup, once a huge part of the cultural life of the area (and neighbouring South Yorkshire and North Nottinghamshire). Accompanied by the Derby Tup song, a blackly comic piece about a ram of grotesque proportions, it was performed in the local pubs, through groups visiting house-to-house, and at focal points such as Chesterfield's Market Pump – usually by a group of boys in their early teens. The text of the play and song were handed down orally from one generation of Tuppers to the next. Folk song scholar Ian Russell made a lengthy survey of the custom, following a number of Tup teams across North East Derbyshire, publishing the results in a 1979 edition of *Folk Music Journal*. Within the generation since that article was published, it has all but died

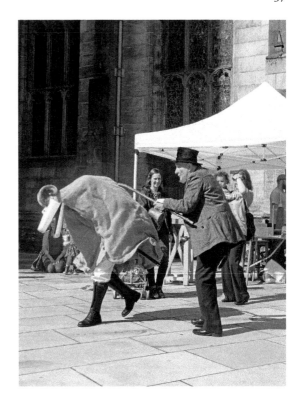

Right: The Derby Tup performed by Handsworth Sword Dancers, Sheffield Cathedral, 2015.

Below: The Derby Tup performed by Harthill Morris, The Phoenix, Ridgeway, 2015.

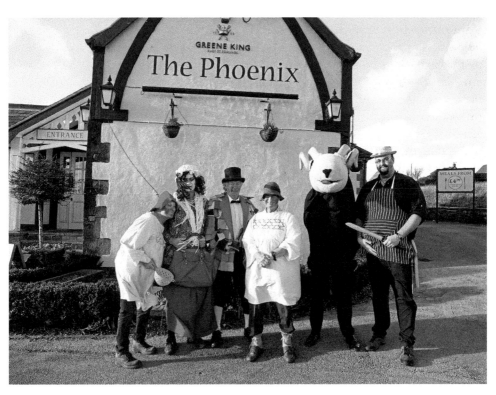

out (but is kept alive by a few groups over the border in South Yorkshire (whose teenage years are a good way behind them) – pictured (on p.37) are the Handsworth Sword Dancers and Harthill Morris teams performing the act in 2015).

One high-profile Tupper who went on to have considerable sway over the day-to-day running of Chesterfield is John Burrows. I received a tip-off into this little-known aspect of the life of the former leader of Chesterfield Borough Council, who stepped down from the role in May 2017, from Pat Bradley – no relation as far as either of us were aware. Pat had responded to a letter I had written to the *Derbyshire Times* in 2016, and remembered the large Burrows family performing the act at Duckmanton where she had grown up. I got in touch with John, and in spite of his busy schedule helming a council who at the time were presiding over the replacement of Queen's Park Sports Centre and toying with a controversial scheme to link Chesterfield to Sheffield City Region, he replied to me quickly. From the opening lines of his email, it was clear he had not forgotten the act: 'In my finest singing voice! "as I was going to market upon a market day, I met the finest ram that ever was fed on hay NANNY GOAT LAY, NANNY GOAT LAY" ETC, "Is there a butcher in the house" "our Bobs a Blacksmith" "ok then! He'll have to do."' Although the Tup is normally a sheep, John played the part of a pig in a wheelbarrow who was slaughtered – Russell did find other local examples of the Tup being an alternative beast.

Talk of the Derby Tup brought back a mixture of pleasant and painful memories for Harry Perkins, who grew up at Stanfree in the 1950s. Harry performed the act in the local area with a group of around five of his pals aged eight to fourteen years. Harry's wife Gill told me

> they would walk all the way from Stanfree to Hillstown and back, starting at The Apple Tree [pub] and calling at various houses just knocking on doors and performing all the way, some made a donation but others didn't if the man was out of work etc. They used to get a decent amount from Hillstown Club and so enjoyed doing it there, the older ones would teach younger lads and it carried on for quite a few years, it had been going on for quite a while before Harry was 'recruited'.

It was at the Hillstown Club where Harry, playing the Tup, was once knocked out cold during the 'death' scene. Wearing as his costume 'an old ARP helmet covered with a sack', the butcher delivered the fatal blow with an axe, accompanied by a dramatic drum crash 'that frightened him to death'.

The performance lives on in the folk memory of the area with the incorporation of the Derby Ram into the town's coat of arms, which can be seen on the bridge linking buildings on New Beetwell Street. Another reminder of the Tup's heyday is The Derby Tup pub on Whittington Moor, formerly the Brunswick Hotel.

While the Tup was the dominant dead animal-based Christmas custom in the Chesterfield area, around Eckington, Dronfield and the north of Chesterfield, another creature was abroad – the Poor Old Horse. Again this centred on a song, with the part of the creature acted out by one of the performers. S. O. Addy remembered the Poor Old Horse from Dronfield and Norton (now part of Sheffield but formerly in NE Derbyshire) when he was a boy around 1855. Chesterfield folk dance and drama collector

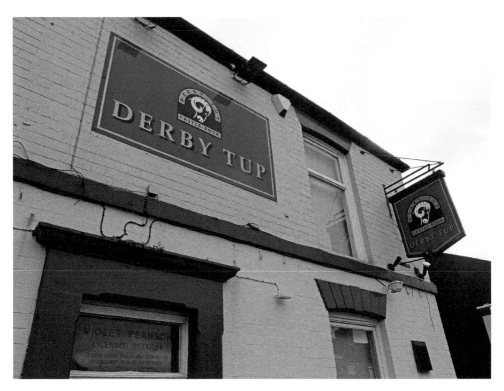

The name lives on ... the Derby Tup pub, Whittington Moor.

William J. Shipley spoke to an unnamed old lady in 1931, who remembered a visit from the horse to Staveley when she was a young girl around 1865 – something which she found a frightening experience. The enactors were termed 'morris dancers' and the lady remembered them coming into her father's yard around Christmas time (he wouldn't allow them into the house as they were 'so rough' with 'grotesque caps and faces') and set up a big wooden horse with wooden pegs for teeth. Addy also remembered the horse as having a wooden head, although in other accounts a real horse's skull, sometimes painted and with additions of a cloth tongue and bottle-top eyes, was employed.

In 1981, folklore researcher (and co-founder of Chesterfield Morris Men) Dave Bathe interviewed Jim Heath, then aged seventy-four, who grew up at New Whittington where his father (J. W. Heath) ran the local butcher's shop. At Christmastime they used to supply local lads and men with the cleaned-up skulls of cows, sheep and horses for use in the Christmas visiting customs. The horse's heads were procured from Clayton's Knacker's Yard, a tannery in Chesterfield. 'It was a regular thing – he used to expect them at Christmas time,'[11] Heath told Bathe. The horses used to be specially slaughtered with a sledgehammer to leave the head undamaged, and the head cut off cleanly. The flesh would then be burnt away, leaving some hide on the head. The shop boys at Heath's

11 University of Sheffield Dave Bathe Collection ACT/97-003/1/2/3, Bathe's notebook

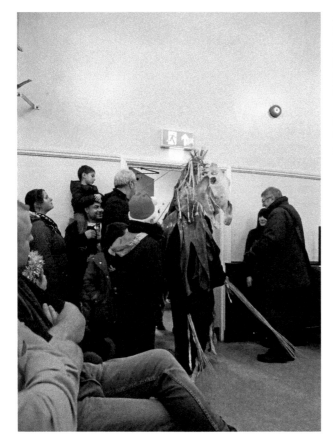

Above: Members of the Old Dronfield Society perform Poor Old Horse, 1991. (Image reproduced with kind permission of Dronfield Heritage Trust)

Left: The Poor Old Horse rides again, Dronfield Christmas celebrations, 2016.

father's butchers had the job of skinning the sheep and cow heads, and removing the cheeks, tongues and brain. The remains were then painted and decorated by the guisers.

The final local business to get involved in the enterprise was John Green's timber yard at Whittington Hill, who used to fix the heads up on a 'cross-piece' and then on to a stout pole. A cloth was then attached to the head, which the performer crouched underneath. Heath told Bathe that to give the head an especially eerie appearance on a dark midwinter's night, sometimes the participants lit up the head with a carriage candle cut in half and placed in the eye sockets.

The Poor Old Horse was performed by a Dronfield team up until the early 1970s. The prop horse was afterwards stowed away in the attic of the family home of one of the performers, Billy Ralphs. The Old Dronfield Society were fond of the custom and retrieved the prop for a couple of performances for members of the society in the early 1990s. Following these, the horse mysteriously vanished and its current whereabouts are unknown.

Recently, a new horse prop was made by Dronfield Hall Barn's artist in residence John Sutcliffe. An open arts call was put out by First Art to create a performance piece based around the custom. This was won by Eoin Bentick and Rob Thomson who worked with students from Dronfield Henry Fanshawe School. The subsequent performance was given to an audience of slightly bemused townsfolk in the Peel Centre as part of Dronfield's Christmas lights switch-on festivities in 2016.

Another popular mumming play was based around the life of legendary folk hero Robin Hood. The *Derbyshire Times* of 2 January 1869 reported on 'The Christmas Festivities of 1868' as practiced in the streets of Chesterfield on Christmas Eve where, as well as the Waits and the Derby Tup, the townsfolk were entertained by a troupe who 'seemed to be an importation of Staveley colliers who came to try their luck at the town of the crooked steeple'. Unfortunately, one of the players was suffering from what these days would be termed a 'wardrobe malfunction': 'A lot of people who had congregated round the band seemed to be picking fun out of one of the "Mummers" who was desirous of being unnoticed. The lads cheered, and upon going to see what was the reason it was found that one of the men, who was dressed in female attire to represent "Maid Marian" in the play of "Robin Hood and Little John" had some of his attire dangling around his legs in a decidedly inelegant style'.[12]

12 *Derbyshire Times*, Saturday 2 January 1869, p. 3

5. Culinary Chesterfield

If you asked someone to name a distinctive regional Derbyshire dessert, probably 95 per cent would opt for a Bakewell Pudding, that serendipitous sweet that, as the story goes, a flustered cook who did not fully understand the instructions issued to her accidentally rustled up in the kitchens of the town's Rutland Hotel. However, Chesterfield and the surrounding towns and villages have supplied the recipe books with several obscurer sweet dishes.

Chesterfieldians have something of a sweet tooth. Several confectionary manufacturers have operated in the town over the years. Samuel Elliott established his business in 1892 and advertised in the souvenir brochure for the 1910 Shopping Festival; his usage of capital letters is almost as dubious as the claims he made for his products on medical grounds:

> 'Sugar is a food, and is becoming more and more a Chief Food of our Nation. Doctors and Scientists realise this and recommend Sweets in their many and varied forms, knowing that in addition to the taste being pleasant – Sweets made of Sugar give the Food necessary in building up Healthy, Strong and Vigorous Bodies.'[13]

Elliott highlighted two of his specialities: 'Boiled Mixed' ('The Delight of the Home: Once tried – always wanted') and 'Our Darling's Mixed' ('The Children's Delight: Once tasted – always asked for') and issued the invite, 'When in Town try a Drink from My Soda Fountain.' His sweet shop on High Street sold his 1,000 different lines (including Chu-Mints, Chu-Chocs, Tippits, Koffettes, Coffee Dainties and Limekwenches), manufactured from his premises on Park Road and Quarry Lane, Brampton. Operations ceased in 1959.

Another confectioner operating in the town who was featured in the 1899 *Illustrated Guide* to the area was Samuel Clark of Vicar Lane. The guide's writer visited the firm's boiled sugar goods department where they sampled 'some delicious almond toffee, and other sweets flavoured with pine apple [*sic*], lemon, raspberry, and other compounds, together with "Snowballs" and "Japs," much favoured by customers in this neighbourhood'.[14]

A more widely known brand who operated in Chesterfield for many years was Trebor, who bought the former Chesterfield Brewery premises during the Second World War and converted them into their factory. 'Wickerman', a sprawling eight-minute-long epic track on Pulp's final album *We Love Life*, documents a journey of discovery lyricist Jarvis Cocker undertook by inflatable canoe along Sheffield's River Don. The lyrics refer to a Trebor factory, which burnt down in the 1970s, but Jarvis admitted in his 2011 collection of lyrics

13 Chesterfield Shopping Festival Programme (1910), p. 40
14 Midland Railway Co. (1988), p. 68

Mother, Brother, Lover that artistic license had been employed here, in that the Trebor factory in question was not actually the one on the banks of the Don at Hillsborough, but a sister operation in nearby Chesterfield. I haven't been able to find any reference to a fire at the factory so far, although in response to my appeal to the Old Chesterfield Pics Facebook group Keith Sanderson remembered a fire at the Kennings garage opposite Trebor.

In a section on regional food in an obscure mimeographed pamphlet from 1954 entitled 'Legendary Lore of Derbyshire', nestled up against the familiar story of Bakewell Pudding's genesis and Ashbourne gingerbread, was a passing mention of a 'Langwith Pudding'. Langwith is collectively formed of a group of six villages on the Derbyshire-Nottinghamshire border, 4 miles from Bolsover (and eight from Chesterfield). I asked my mum and two of my aunties if they had ever heard of such a dish, but they hadn't. Next I contacted Langwith Parish Council regarding the mystery pudding. Council administrative assistant Aleah Bates replied that she had asked around the local councillors and none of them had heard of it either. To add to the mystery, if you type 'Langworth P...' into Google, it auto-predicts that you are searching for 'Langwith Pudding' and 'Langwith Pudding Recipe', suggesting that previous Googlers have also tried to find information about it. Given the volume of visitors that pour into Bakewell daily and spend money there consuming the town's iconic sweet dish, Langwith Parish Council could be missing a trick here.

Bolsover itself has its own signature pudding, the Bolsover Cake (which none of my family had heard of, either). A recipe is included in John Dunstan's collection 'Old Derbyshire Deserts' for this dried fruit cake, which when first devised was made with bread doughs spiced with ginger and cinnamon. According to John, the cakes somehow symbolised prosperity and fertility, and he reports that competitions to find the best Bolsover Cake are still staged in the town. Bolsover Castle's website promises that Bolsover Cake can be sampled at the castle tearooms, although on my October 2017 visit there was no sign of any, and when I made enquiries I was told that they rarely had any in.

During the 1850s, the winning combination of a lottery and outsized cakes briefly caused a stir in Chesterfield. John Poole, an enterprising baker originally from Mansfield who had set up a bakery at the now-demolished Cross Daggers pub in Market Place, expanded on the traditional concept of including threepenny bits in Christmas pudding by baking a large cake (termed a 'Monster Cake') that contained gold rings secreted inside. For a shilling for a pound of cake, purchasers also had the chance of winning a ring.

In the run up to Christmas 1855, the publicity-savvy Poole took the concept further, this time the prizes included silver teapots and watches – needless to say, these were no longer baked in the cake, prize tickets being issued instead. The 1855 Monster Cake was so big it weighed a ton, was 6 feet 6 inches in diameter and 3 feet 4 inches high. In late November 1856 Poole was promising in the local press 'to surpass his former efforts by making the Largest and Best Cake ever made in the World! which will be of the Enormous Weight of UPWARDS OF THREE TONS!'[15] By this time a rival baker named Reynolds had got in on the act baking his own Monster Cakes, although neither the quality of his prizes nor the scale of his cake could match Poole.

15 *Derbyshire Times*, Saturday 29 November 1856, p. 2

Jacksons the Bakers, whose wonderfully old-fashioned shop is on Low Pavement, make cakes at Christmastime to order under the name Monster Cakes – although these modern-day incarnations are not seemingly much larger than the average cake and mere tiddlers by comparison to Poole's leviathans of the 1850s.

Ice cream is made in Chesterfield by the long-running Fredericks firm. It was 1898 that Angelo Frederick and his two brothers set out from Parma, Italy, to England on foot in search of a better life. Angelo settled in the Don Valley area of Sheffield. In 1925 his son John made the slightly less epic journey from Sheffield to Chesterfield, and ice cream including their signature '1898 blend' and 'Pomegranate Aspire' in reference to the pomegranate plant on the town seal is still made at their Brampton premises. Their fleet of vans is a common sight across Derbyshire during the summer months. My dad remembers his school friends earning pocket money in the summer holidays in the 1950s by turning up at the factory to commandeer 'Stop Me And Buy One' bicycles, which they then pedalled around Queen's Park.

With all these local sweet treats on offer, we could do with something to wash them down. Thankfully, over the years Chesterfield has had several high-quality tea merchants. There was Hunters Tea Stores at Whittington, as well as C. Mason's on Packer's Row; photos of it show a fern and foliage-bedecked shopfront bearing signs promising 'A Good Assortment of Biscuits 7D' and 'A Choice Assortment of Chocolates'. A larger operation were Messrs. E. Woodhead & Sons Ltd., Family Grocers and Tea Dealers, based

Jacksons the Bakers shop on Low Pavement.

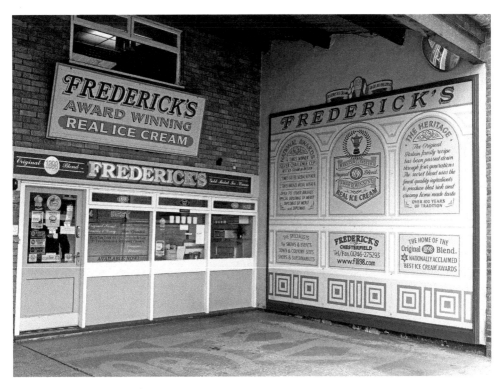

Fredericks Ice Cream headquarters at New Brampton.

at High Street, with offices and wholesale warehouses off Packer's Row. The firm was established by James Woodhead of Liverpool in 1829 and enjoyed a long life, closing in the early 1960s. The High Street shop also featured a large 'Oriental Café', billiards room and dining rooms on the first floor, described in the *Illustrated Guide To Chesterfield* as 'one of the unique features of Chesterfield' (except that it wasn't, as the same feature went on to talk about the firm's recently opened Oriental Café at Bakewell, 'at which visitors to Haddon and Chatsworth are catered for'). The business also had shop branches at Hasland, Bolsover, Hillstown, Mexborough, Poolsbrook, Mansfield, and elsewhere. In addition to tea they also offered the people of Chesterfield coffee 'fresh roasted daily by steam power ... the increasing demand is the best guarantee of the popularity of this stimulating beverage'.[16]

The tea flag is kept flying in the town by Northern Tea Merchants. In 1926, Albert Pogson moved from Lincoln to Chesterfield to take a sales job with the Ceylon Tea Growers Association. After ten years he decided to set up on his own, forming the Spire Tea Co. Albert's son David established Northern Tea Merchants in another area that wasn't competing for business, and on Albert's retirement in 1970 the companies were amalgamated.

16 Midland Railway Co. (1988), p. 54

Historic packaging from Northern Tea Merchants predecessor, the Spire Tea Co. (With kind permission of Northern Tea Merchants)

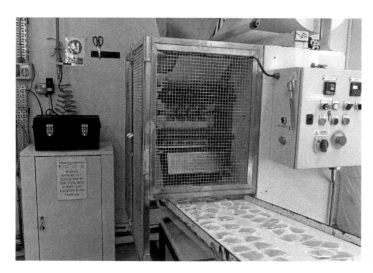

Northern Tea Merchants tea bags in production.

I was shown around the firm's Chatsworth Road premises (a former salt works) by David's son and co-director James. In addition to the ground-floor café, behind the scenes the firm's ranges of tea and coffee are blended and roasted. I was taken to the top of the building and shown a large metal blending wheel – the last thing to be made by Chesterfield Observatory's Horace Barnett (*see* 'Broaden Your Mind') before his death. The tea leaves are churned round in here to create the distinct blends, before descending to the next floor. David was quick to embrace the new-fangled tea bag in the 1960s, and I watched a machine, which filled and sealed four tea bags at a time, producing 600 a minute – quite a hypnotic experience.

It was clear from my trip behind the scenes that Northern Tea Merchants put a great deal of effort into producing a quality product. 'Every day we get at least one person visiting who's made a special trip of over 30 miles,' James tells me, 'Which is a nice feeling'.

I have not managed to dig up anywhere near as much information on local savouries during my research, but there was one curious former Chesterfield byelaw which required local butchers (formerly clustered around the Shambles) to ensure that any bulls slaughtered for beef were beforehand baited in the Market Place. If this law was not complied with, a fine of 3s and 4d was due. It is believed that the natural incline of the Shambles was exploited, the blood of the slaughtered animals running downhill into the River Hipper below. Ironically, the Shambles, where these rivers of blood formerly flowed, is now the location of Thyme To Eat, an excellent vegetarian café.

DID YOU KNOW?

Pulp's guitarist Mark Webber grew up a nail varnish-wearing David Bowie obsessive in Chesterfield, progressing from fan of the band to running their fan club to joining them live onstage, before becoming a fully-fledged member in 1995. A dour, yet catchy 1986 Pulp ballad from well before they were famous, 'Dogs Are Everywhere', was written following a fractious concert in Chesterfield where the 'doggish' (according to Cocker) behaviour of former band members Pete Mansell and Magnus Doyle, including stealing some beer from behind the bar, led to an almighty argument between the venue owners and the band.

Having literally changed the world with his inventiveness, George Stephenson kept his busy mind active upon retirement. Originally from Northumberland, following his work on the Clay Cross tunnel the largely self-educated Stephenson took a shine to the area and settled at Tapton House. Here, following his retirement from his impressive career, he pottered about the gardens growing exotic fruits such as pineapples, peaches, melons and grapes in his glasshouses. Several of these netted him prizes at local horticultural shows, and a keen rivalry for the top prizes developed between Stephenson and Chatsworth's garden designer Joseph Paxton. Applying a similar level of precision and perfectionism to his vegetable growing as he did to fine-tuning the efficiency of the locomotive engine, Stephenson commissioned special glass tubes that were utilised to ensure that his cucumbers grew perfectly straight. Two can be seen exhibited on permanent display at Chesterfield Museum in a section devoted to the town's famous adopted son. Next he turned his attention to melons. Pendleton and Jacques (1903) relate the technicalities: 'He invented a method of suspending melons in baskets of wire gauze, whereby the tension on the stalk was reduced, so that nutrition could proceed more freely and the fruit develop more largely'.[17]

17 Pendleton & Jacques (1903), p. 141

George Stephenson, inventor of straight cucumbers. Oh, and public railways.

Stephenson died in 1848 and is buried at Holy Trinity Church. The zeal for perfect cucumbers was continued after his death by another member of Chesterfield's high society, C. P. Markham, industrialist and three times Mayor of Chesterfield. The East Derbyshire Field Club visited Markham and his wife at home at Ringwood Hall in 1915, where 'In the cucumber house Mr. Markham pointed out the effects of electricity on the growth of the plants, limiting the period of growth by at least one-third of the usual time.'[18]

Finally, one legendary Chesterfield character who surely deserves a place in the annals of the town's history is 'Pound A Bag Man', or Roy Davidson as his birth certificate would have it. Roy, who passed away in 2011 at the age of eighty, formerly plied his wares from outside his Cheese Factor shop in the Market Hall, now run by his son Simon.

If you're trying to establish whereabouts in the UK someone grew up, then ask them what they call a round piece of bread which you would cut in half and insert something into to form a sandwich; to others it may be a breadcake, a bap, or a barm, but the good folk of Chesterfield call a cob a cob. Roy in his heyday would sell you a bag of cobs for a pound.

His death made headline news in the *Derbyshire Times* and at one point Facebook's 'Fans of Chesterfield Market's 'Pound A Bag' Man' group had over 2,000 members. Local singer-songwriter Ian Hoare was moved to pen a song in tribute to Roy: "'Pound a Bag", I bet they were his first words', speculates Ian, before remembering 'his market cries /the soundtrack of a town and when the wind was blowing right you could hear his voice for miles/as he echoed round Chesterfield/in his own familiar style'. 'I didn't know him well – I didn't even know his name – but town won't be the same', concludes Ian sadly.

18 *Transactions EDFC* (1915), p. 31

6. Water

In the twenty-first century, turning on a tap in order to wash our hands, draw a bath, make a cup of tea or water the garden is an act that we perform on autopilot. As a proportional fraction of Linacre, Ogston or Derwent reservoirs gurgles out of the tap, we rarely spare a second thought for where the water actually originates.

Our ancestors could not afford to be so blasé, and the majority of the towns and villages that we call home in the present day owe their location to their proximity to a reliable water source. As the centuries passed and people's knowledge and skillsets expanded, for those who had the means, ingenious methods could be employed to convey water over longer distances. Half-hidden on the hillside of Bolsover lie a series of small stone-built structures, clearly somehow connected to the castle on the summit. Often assumed – by locals as well as visitors – to be some sort of sentry boxes used for the defence of the castle, in fact these are 'Cundy Houses'. 'Cundy' is a corruption of the French word 'conduit' (imagine French filtered through a Bolsover accent) - there is also a Cundy Road in the town (as well as a Conduit Road). The 'Houses' were used to pipe water up the hill to the castle. It is a little obscene to now reflect that, while for most everyday folk obtaining water was still a daily struggle, the Cundy House system was partly employed for the frippery of supplying the water for the ornamental Venus Fountain in the castle grounds.

Well dressing is one of Derbyshire's best-known customs and is originally thought to have stemmed from our ancestors decorating their local wells and springs with natural materials in gratitude for nature's gift of water – a practice possibly dating back to the pre-Christian era when nature spirits were worshipped by the ancient pagan Britons. The tradition, which runs throughout the summer months, is most widely associated with the limestone White Peak area of the Peak District. The estate village of Tissington, generally regarded as producing the most consistently impressive dressings, is one of the first places to stage their dressings around Ascension Thursday and is thought to be the place that has dressed their wells for the longest. When I visited the well dressings at Tideswell in June 2017, the information board noted that the number of well dressings annually produced were on the increase, spreading to the gritstone areas of the Peak District, 'and even as far afield as Chesterfield'.

This is a little disingenuous on the part of the folk of Tideswell, who revived dressing their well in 1946, as not only are villages well beyond Derbyshire – including Malvern in Worcestershire, Frome in Somerset and Holywell in Cambridgeshire – increasingly trying their hand at well dressing, Chesterfield and North East Derbyshire in fact have a historical pedigree for producing well dressings, and unbeknown to anyone at the time I was in Tideswell, within the space of a few months Chesterfield well dressings were to become internationally famous.

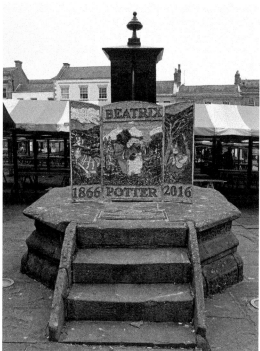

Left: Chesterfield Crooked Spire well dressing, 2016: Battle of Chesterfield design.

Right: Chesterfield town pump well dressing, 2016: Beatrix Potter design.

The first recorded example of a well dressing at Chesterfield dates back to October 1864, when, according to publicity prepared by the Borough Council, the town pump in the Market Place was dressed following a notably dry summer. The cast-iron pump was installed in 1853 with a well sunk to a depth of 11 metres (12 yards) in order to supply the market traders, with water also being pumped onto water carts and distributed elsewhere in the town. It very nearly had a short lifetime: by 1881, the Market Committee were recommending that it be removed on the grounds that 'the pump was neither an ornament, nor supplied any water, and that the place which it occupied was valuable for letting out for stall purposes ... They considered that such an erection was an injustice to their property'.[19] At a meeting of the Town Council, Alderman Wood (of Almanac/Alpine Gardens/Queen's Park fame) was all set to adopt the motion to remove the pump until its designer, Samuel Rollinson of the Highways Committee, leapt to its defence. According to a newspaper report of the council proceedings, 'The top of the pump had been taken off, and Mr. Rollinson had been seen peeping down into the bowels of the earth.'[20]

19 *Derbyshire Courier*, Saturday 15 October 1881, p. 8
20 *Ibid*

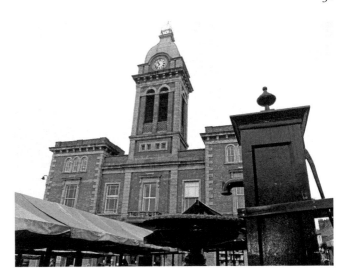

The town pump undressed.

During the time of the Low Pavement redevelopment in the 1970s (*see* Façades), it was restored and smartened up by Markham & Co., who offered their services free of charge. It has provided a convenient platform for public speakers over the years; anecdotal tradition has it that John Wesley preached from the town pump in the marketplace in 1777 (although if this is the case it must have been a predecessor to the current one).

However, the *Derbyshire Times* of 1 October 1864 says that it was the Horns Pump that was dressed:

CHESTERFIELD WELL DRESSING. To commemorate the unfailing supply of water which the Horns Pump has afforded during the late draught, a WELL DRESSING will take place in a field near the Horns, on Monday and Tuesday next. Tea on the Table at Half past Four o'clock, and Dancing to commence Six.[21]

The Market Place pump would hardly be likely near a field – even back in 1864. Given its name it is probable that this pump was located near the Horns Bridge. In 1868, the Horns Pump was again dressed after Chesterfield had suffered another October dry spell, the *Derbyshire Times* remarking,

This pump has been gaily decorated with evergreens, flowers, &c, to show in how great esteem it is held by the people who draw their daily supplies from it, and were it not for its supply, and that of the Market pump, and others, Chesterfield would be badly off indeed. If the suicidal tendency of those who called these pumps unsightly, and wished to have them removed, had been carried out, it would have been but little avail to cry out for water from the Water Company in the present crisis.[22]

21 *Derbyshire Times*, Saturday 1 October 1864, p. 2
22 *Derbyshire Times*, Saturday 3 October 1868, p. 2

The practice lapsed, but was revived briefly in the town in the early 1960s thanks to Philip Rudkin, the art master at Brambling House School (nowadays St Peter & St Paul School). Mr Rudkin had taken a group of forty pupils on a school trip to see the well dressings at Youlgrave (another prominent well dressing village), and thought the custom could be attempted by the school. Under his supervision pupils made a well dressing in 1960. Undeterred by the fact that their site didn't actually contain a well, the pupils constructed an artificial one as well! Their dressing went on display at the school's Garden Evening fundraiser event, the design depicting St Francis of Assisi feeding the birds. Designs in subsequent years portrayed St George and the Dragon and St Patrick, but then in 1962 Mr Rudkin left the school to take up a post outside of Derbyshire, and that was the end of well dressing in Chesterfield for another three decades.

DID YOU KNOW?
Linacre Reservoirs are located on the site of Linacre Hall, built by Thomas Linacre (1460–1524). Born in Brampton, Thomas was a learned gentleman; having attended All Souls College at Oxford University, he subsequently founded Linacre College there. His memorial tablet in Old Brampton Church states, 'To him was chiefly due the revival of classical learning in this country'. His other achievements included a spell as Henry VIII's physician and establishing the Royal College of Physicians. By the nineteenth century the hall had become a farmhouse and was subsequently demolished to make way for the reservoirs.

The custom was again revived in 1991 when an exhibition about Derbyshire traditions was staged at the Peacock Centre, a well in the courtyard being decorated to accompany it. Since then the town has annually produced between one and five dressings. With the relocating of the Tourist Information Centre to newly built premises at Rykneld Square in 2002, the Peacock well was no longer dressed, and from 2004 the pump in the Market Place was decorated instead. A dressing has also been displayed in the porch of the church most years since the 1991 revival.

One damp and misty September morning I headed over to the Crooked Spire, where upon entering the archway I found a group of ladies huddled together, one of whom was grinding nutshells into the gravestones that carpet the porch with the heel of her shoe. No! This wasn't a secret coven using the church premises to perform some sort of satanic ritual, rather the ladies of the Crooked Spire Flower Guild, busy at work in producing one of 2017's well dressing designs. I was informed by one of them that the dressing is located in the porch because somewhere deep down below us there actually was a well that formerly served the church. To fully appreciate the supreme amount of effort and artistry that goes into creating a well dressing, I would recommend seeking out a well dressing location which, as Chesterfield does, invites members of the public to witness the 'petalling' process in the week leading up to the boards being erected (details can be

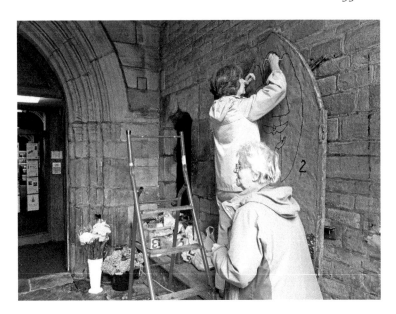

Well dressing under construction, Crooked Spire, 2017.

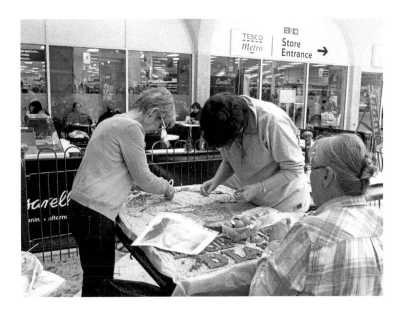

A controversial artwork in the making: town pump Princess Diana design, 2017.

found on the excellent resource welldressing.com). It is eye-opening to see the level of patience and the range of paraphernalia involved: where the painter would reach over to their palette to select a certain colour or texture, the well dressers surround themselves with blooms of every hue as well as the wide array of natural materials that go into making up the designs (pine cones, wool, moss, bark, coffee beans, etc.).

I left the guild members to carry on with their work and made my way across town to The Pavements shopping centre, where an even more surreal tableaux presented itself. As crowds of shoppers scurried determinedly to and fro keeping the wheels of commerce

grinding, in a little fenced-off enclosure outside Massarella's Café a group of women sat hunched over a series of low tables crushing up tiny bits of eggshell and carefully arranging them to form a simulation of Princess Diana's face. This subject had been chosen as 2017 marked the twentieth anniversary of her death, and also as The Pavements development and former Tourist Information Centre at The Peacock were officially opened by a recently married Charles and Diana in November 1981, making it an early engagement four months into her tenure as the Princess of Wales.

The well dressings I had seen being made went up on Saturday 9 September. On Tuesday 12th, Chesterfield Borough Council innocuously shared a post promoting the fact that they were on display, with photos of the Market Place design in place. The subsequent reaction came very close to breaking the internet.

Although the dressing had been up for four days, it seemed to have passed many of the townspeople by (several locals commented on the Facebook post that they weren't aware that Chesterfield produced a well dressing, or even that there was a pump in the middle of the Market Square). Through being shared on Facebook by the well-meaning council, more people quickly became aware of it, and the photos provoked a range of reactions from genuine anger to hilarity and caustic sarcasm.

Chesterfield and its well dressing found itself in the unlikely position of 'going viral', with the story being picked up within hours by the BBC News website, the *London Evening Standard* (who for the benefit of its readers in the bubble of the capital helpfully described the town as 'Chesterfield, near Sheffield'), *The Telegraph, The Sun, The Daily Mail, The Independent* (who elevated the status of the local authority to Chesterfield 'City' Council) and *The Guardian.*

The royal family had previously proved a popular choice of subject for the Chesterfield well dressers to tackle, with the 2002 and 2012 designs depicting Elizabeth II's Golden and Diamond Jubilees, and the 2011 Market Place design commemorating the marriage

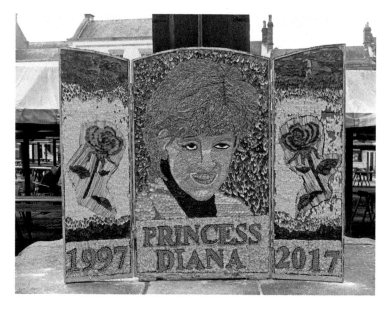

The finished article: town pump Princess Diana well dressing, 2017.

Close-up of Diana's face design.

of Prince William and Kate Middleton. The death of Diana in 1997 prompted a mass outpouring of previously pent-up emotion from the British public, and it seemed that the well dressing tribute had unwittingly unlocked these same floodgates again twenty years on. The spiralling reaction stemmed from the realisation of Diana's likeness, which days earlier I had seen the dressers hard at work on. Replicating the human face is something that is notoriously tricky in well dressing, and the end result had turned out a little, shall we say, wonky. What had clearly been conceived as a well-intentioned tribute had been mystifyingly interpreted by many – initially people from Chesterfield, followed by members of the public in many countries across the globe as the story spread like wildfire – as a deliberate slur. One American lady in a comments section of the story being reported on the website royalcentral.co.uk, felt with certainty she had uncovered the motives of the Chesterfield well dressers: 'That flower display is not "art". It is a horrible site set up by Camilla supporters who are showing how they think Diana should be portrayed to anger people who liked Diana and loathe Camilla.'[23]

Other people focused on speculating who they interpreted the likeness to more closely resemble, suggestions ranging from Worzel Gummidge, Alan Partridge, Theresa May, Thom Yorke in a wig, and Rod Stewart to Clare Balding. Thomas Hunt observed, 'It looks like a cross between Bonnie Tyler, a hedgehog and Janet Street Porter.'

I visited Chesterfield as planned the day after their dressing made headlines across the globe. I was intending on visiting to photograph the well dressing as a matter of course (along with its sister one in the Crooked Spire porch and a small additional one at Spital Cemetery, neither of which the world's media had bothered to mention), but half thought that the Market Place might be filled with baying hordes as a result of the

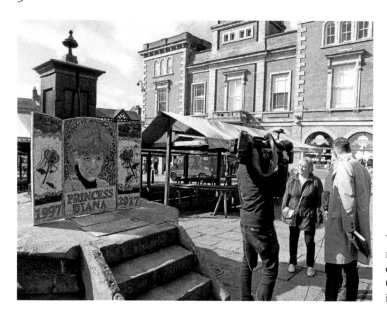

The world's media descends on Chesterfield – Channel 5 News crew interviewing locals.

firestorm and I might not now be able to get near it. When I arrived all was fairly quiet, however, Wednesday is not a full market day but there were a couple of scattered fruit and veg stalls set up, and a few curious souls checking out the dressing. A camera crew from Channel 5 News were also prowling around, squabbling between themselves about their tracking shots. They coerced me into being filmed taking photographs and doing a short interview with them, during which I explained to them the pedigree and history of well dressings and told them that given how much effort goes into all the well dressings across Derbyshire every year, it was a shame it took Diana's slightly wonky eye to get people like themselves sufficiently interested to journey up from London (unsurprisingly, they chopped that bit out of that evening's broadcast).

Reports from old local newspapers reveal that wells in numerous surrounding villages also have a history of being dressed. Holymoorside dressed theirs sporadically from at least 1848 onwards until sometime around the turn of the century, restarting in 1979 after an eighty-year interval. A well at Wadshelf on the Chesterfield to Baslow road was dressed between 1844 and 1846, and one at Heath dressed in 1859. Barlborough dressed a well in 1875.

The village of Barlow anecdotally claims to have been dressing their well since Elizabethan times, which would potentially give the custom as great a pedigree as that claimed by Tissington. The first recorded reference to a dressing here comes from the *Derbyshire Courier* newspaper of 19 September 1846. Well dressing is a highly picturesque custom, perhaps even borderline twee. However, every now and then an arresting and thought-provoking design comes along. The Barlow dressers produced one such example in 1938 with a design entitled 'The Price of Coal'. In the background of the dressing is a colliery winding engine and spoil heap. To the foreground, a woman clutching a baby and holding the hand of a young girl looks expectantly towards a nurse stood by an ambulance. The dressing commemorates the Markham Pit disaster of that year in

To boldly go... Detail of Holymoorside 2016 Star Trek design.

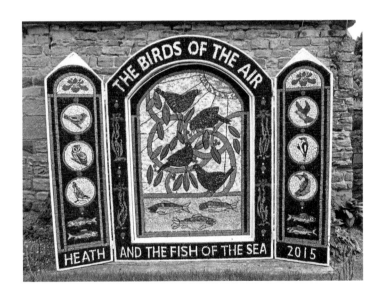

Heath well dressing design, 2015.

which an underground explosion killed seventy-nine miners and severely injured forty others. The same colliery was struck by tragedy again in 1973 when a descending lift cage containing a group of miners failed to slow adequately at the bottom of the shaft, killing eighteen men including Lucjam Plewinski, the second husband of my grandfather's sister Alice (who under her previous married name of Alice Pollard was Chesterfield's first ever female police officer).

Barlow and nearby Cutthorpe are unusual in that they produce their well dressings using whole flower heads rather than individual petals, and their wells are dressed on-site in a triptych design rather than, as at most other places, made in a barn, church, community centre, etc. and then brought to the display site once completed. Highlighting

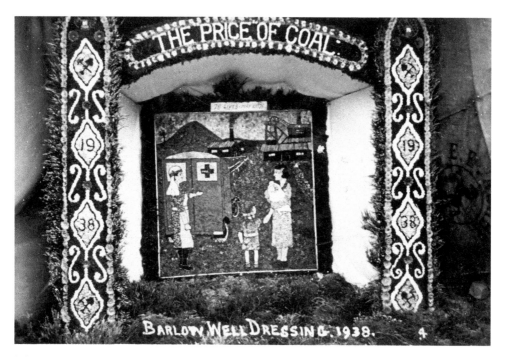

'The price of coal': Barlow Markham Pit Disaster design, 1938.

the primal nature of the custom, at Cutthorpe in the pre-welfare state world of the 1940s, Crichton Porteous encountered local men working on the well dressings who had sacrificed either a week's pay or their entire annual holiday allowance in order to produce them.

DID YOU KNOW?
In an age before mass mobility, it was rarer for people to leave their home villages and intense feuds could develop between neighbouring settlements. Chesterfield resident Angela Barton wrote to folklorist Charlotte Norman to inform her that around the turn of the nineteenth/twentieth century there was a keen rivalry between Barlow and Newbold. Barlow people referred to Newbold as 'Newbold – soft watter [water] town'. This insult stemmed from the fact that the Newbold people had rain butts to catch water, unlike Barlow, which had its much-prized wells.

With our ancestors living in much closer proximity to nature, all the deeply ingrained nature worship, which formed part of the way of life for the native inhabitants of the British Isles and manifested itself in veneration of water, stones and trees, proved much harder to stamp out than the conquering Christians had originally banked on.

At meetings of church authorities edicts were issued banning water-worship, including at the Council of Arles (AD 452) and the Council of Tours (AD 567). Eventually the Christian Church adopted the line, 'If you can't beat 'em, join 'em', and the sacred water sources of the country became Christianised as holy wells. You will to this day find most of the area's well dressings being blessed in a ceremony by members of the Church of England when they are first put up.

Chesterfield had its own holy well, now lost but remembered in the street name Holywell Street. The well was situated in a chapel dedicated to St Helena, a saint often associated with holy wells. Bestall (1974) speculates that the well may have been connected to the Plague, which was prevalent in the area in medieval times, with supplicants visiting the well in hope of a cure. Godfrey Foljambe founded a school on the site in 1594, where the chapel remained until 1710 when new school buildings were built, and the well lost. The school later became the girls' grammar, adopting the name St Helena School, which closed in 1991.

Popular belief in the curative properties of water, whether it be through drinking or bathing in a particular source, continued well into the twentieth century, only really dissipating with the formation of the NHS. In Derbyshire, a lucrative tourism market developed around the towns of Matlock and Buxton for this reason, with visitors flocking to 'take the waters'. Chesterfield and the surrounding district also had numerous watering spots however, all now largely forgotten, and even in their heyday far less celebrated.

The town had its own spa at one point; as with the holy well, though the spa itself is long gone, the memory of its existence lives on in the street name of Spa Lane, a short road leading off St Mary's Gate down to a car park, and also the pub going by the name of Spa Lane Vaults at the junction of both roads. In his 1789 *View of the Present State of Derbyshire*, James Pilkington mentions a chalybeate spring (water containing traces of iron salts) at Chesterfield, noting that when a few drops of Prussian lixivium was added to a sample of its waters, one half turned a fine blue, and the other half a deep green. He was

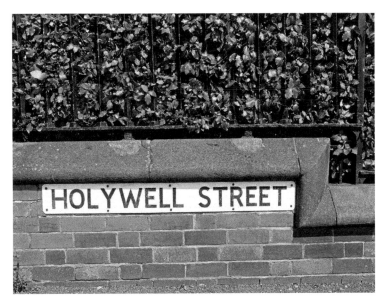

Holywell Street, a reminder of Chesterfield's lost holy well.

Spa Lane Vaults.

informed that when enough of it was drank, it acted as a purgative and 'has been found useful in disorders, arising from weakness and relaxation'.[24] There was also a chalybeate spring located at Tibshelf (again, remembered in the street name Spa Croft), which 'About a century ago ... was much valued, and drank throughout the summer season. But it does not now appear to be in any repute.'[25]

Pilkington also records the existence of a medicinal baths at Shuttlewood near Bolsover fed by a slightly sulphurous spring, although even in the late eighteenth century this was somewhat obscure, as he notes, 'The bath is not covered in or even enclosed with a wall, and the situation being exceedingly inconvenient, it is seldom used, even by those, who reside in the neighbourhood.'[26] Is it any wonder that tourists chose Buxton with its newly opened elegant Crescent instead?

Ashover had two large Victorian hydropathic institutions, which were more of a success. Ashover House Hydro was first to be built in 1869, followed by the Ambervale Hydro. The former operation lasted until 1963.

In an era before a reliable drinking supply was brought into our homes via the tap, mineral waters were once produced in Chesterfield by several manufacturers. Alderman Wood produced some as a sideline to his wine and spirit business; there was also Mr. J. J. Clayton, who operated from Standard Works at Whittington Moor, who also brewed ginger ale, hop ale bitters, and stone ginger beer; and Messrs Simmonite & Sons, based at Saltergate, who had a powerful engine that pumped the 'purest spring water of sparkling quality' used in production from a 95-foot-deep well located on the premises.

24 Pilkington (1789), p. 246

25 *Ibid*, p. 247

26 *Ibid*, p. 239

7. Strange Things Found in Churches

While I am a devout atheist, I still enjoy a good poke around a church. Whatever your religious beliefs, these edifices, which in the twenty-first century all too often find themselves beleaguered by rising damp and falling congregations, can be fascinating places to explore if you poke hard enough into the dusty corners. As well as their more obvious function as places of worship, churches stand as temples of social history given their focal role in the community over the years, and seem to have a surprising knack of ending up as repositories for strange curiosities.

The Crooked Spire of St Mary's and All Saints' Church is Chesterfield's famous landmark, although it is actually far from unique – there are over 130 other known churches with a similar deformity, other UK examples including the churches at Barnstaple and Clitheroe. France is the crooked spire capital of the world, with seventy examples (the French prisoners of war must have felt at home here).

A lesser-known oddity found inside the church is the 'Dun Cow's Rib'. This is supposed to have belonged to a fabled philanthropic beast, the Dun Cow, who would allow herself to be milked by anyone who brought a vessel along to be filled. One day this generosity was exploited by a witch, who brought a sieve. Enraged at being taken advantage of in this fashion, the cow went mad and subsequently had to be slain by Guy of Warwick.

The 'Dun Cow's Rib'. (Photographed with kind permission of the Vicar and PCC of Chesterfield Parish Church)

Hall (1839) ventured an alternative origin for the bone, saying it is 'supposed to be the rib of a Mammoth'. In fact, the previous owner of the bone was neither a Dun Cow nor a mammoth, but actually a young whale, as confirmed by the Natural History Museum in 1992. What a young whale was doing 80 miles inland at Chesterfield is a matter for conjecture – and no one now knows how or why its rib got into the church. The rib is normally found by the Foljambe alter tombs, but at the time of writing was temporarily on loan to Chesterfield Museum as part of a Crooked Spire-themed exhibition held in 2017 – as pictured here.

The north transept of the church was formerly home to a carving known as the Chesterfield Imp or Chesterfield Sprite, who was located above the choir vestry. Unfortunately, he was a casualty of the 1961 fire that broke out at the church, being so badly burnt and smoke blackened as to be thought unsalvageable. Before he was disposed of, the vicar of the time, Revd Dilworth Harrison, commissioned Pearsons Pottery to produce a few copies of the sprite as a record of his existence (one of which can be seen on display in Chesterfield Museum).

DID YOU KNOW?

Former Rector of Staveley Francis Gisbourne (1733–1821) was a great philanthropist, who set up a number of charitable bequests benefitting people across Derbyshire on his death. He had a rather unexpected hobby for a vicar – making his own fireworks. Foster (1894) records: 'He devoted a small room attached to the Rectory to the purposes of a workshop, and he exhibited his fireworks from a high point of ground in his parish, to the great delight of his neighbours, who used to say – "Staley parson is gi'eing a show for nought again."'

A visit to the Saxon Church of St John the Baptist in Ault Hucknall will reward the keen church-crawler (although, in view of its isolated location, it has limited opening times – check in advance of a visit). If you accept that it is the existence of a church that elevates a settlement from a hamlet into a village – a rule which is by no means set in stone – then Ault Hucknall is claimed as the smallest village in the UK, as besides the church all it consists of is a cottage, a farm and one house. The church has acted for over 1,000 years as a place of worship and focus for the settlements in the surrounding countryside.

Outside on a lintel over a blocked-up doorway a scene is carved, which has been interpreted as St George battling a dragon, although the church guide booklet observes that the man's armour appears of the Norman era and therefore predates the adoption in the fourteenth century of St George as the patron saint of England, and posits that the figure may in fact represent St Michael the Archangel expelling the dragon from heaven. Or is it the 'Winlatter Rock' dragon?

The church marks the last resting place of famous philosopher and 'father of modern democracy' Thomas Hobbes, who died aged ninety-one. Hobbes was hired as tutor to

Ancient stonework at
Ault Hucknall church.

Detail of a dragon carved
on lintel at Ault Hucknall.

the Cavendish family (Earls and later Dukes of Devonshire) and insisted at his advanced
age on accompanying the family as they travelled from Chatsworth to their other house
at Hardwick Hall, being carried on a stretcher, and expired shortly afterwards. A black
Derbyshire marble slab inside of this out-of-the-way church marks his last resting place –
an obscure, yet peaceful spot. This bright mind called among his friends fellow thinkers
Ben Johnson, Descartes, Francis Bacon and Galileo. In *Levaithan*, Hobbes postulated
that the natural human condition outside the framework provided by society would be
'solitary, poor, nasty, brutish, and short'; none of these epithets could really be said to be
applicable to his own life.

Thomas Hobbes' tombstone, Ault Hucknall church.

To the pagan Celtic inhabitants of our isles, the human head was prized as a sacred object as it was thought to contain the person's soul. Human skulls were often buried separately to the rest of the body, and heads of rival tribespeople were chopped off and displayed on poles at prominent entry points to settlements to advertise the strength of the community (in a grisly kind of precursor to the 'Welcome to Chesterfield the Centre of Industrial England' signs). If an actual human head could not be found, then one carved out of stone – a material also thought to possess special powers – would suffice as a good alternative. The fact that stone-carved heads are incorporated into the fabric of several of the area's churches suggests that these beliefs lingered on beyond the time when Christianity was adopted as the dominant religion. At Ault Hucknall stone heads can be found on the archway between the nave and chancel, thought to date to Saxon times. The heads are but one element of the carvings that span the archway, which also include humanoid figures. The church guidebook takes the line that this represents scenes from the Bible of the creation, the fall of Adam, the flood and the sacrifice of faith made by Abraham – but is it actually depicting something more mysterious entirely, connected to the old ways before Christianity?

Bolsover Church of St Mary & St Laurence has a collection of six strange animalistic heads, which were found buried beneath the buttress of the chancel in 1961 when new foundations were being dug, now set into the south wall of the choir. They have been dated to the Norman era and are thought to have come from a roof support as at Ault Hucknall.

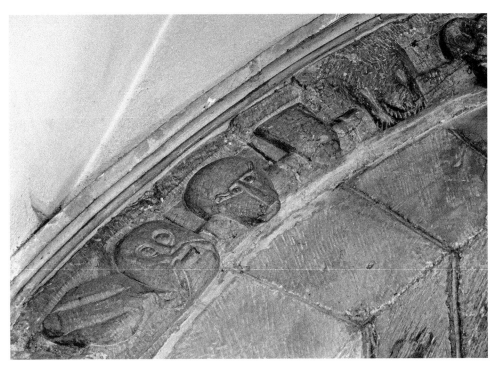

Stone heads on Saxon arch, Ault Hucknall church.

Bolsover church's collection of animalistic stone heads.

Close-up detail of individual heads, Bolsover church.

A clean sweep? Staveley church stone head.

A stone head can also be found on an exterior buttress by the south porch at the Church of St John the Baptist, Staveley. Court (1946) records that this head was in a blackened condition owing to the smutty atmosphere at the time the nearby pits were functioning, leading a slightly fanciful-sounding local legend to arise that the head represented the likeness of a sweep who had fallen to his death from the roof of the church. Unfortunate sweep or not, presumably at some point since 1946 someone has given his rather melancholy-looking face a bit of a wash, as he didn't appear particularly blackened on my 2017 visit (although he was a bit cobwebby).

The Green Man was a pagan fertility figure – half-human, half-vegetation. He turns up in Christian churches with surprising regularity. Examples can be found carved in wood at Ault Hucknall, and also at All Saints, Wingerworth (who term their fine example a 'Jack O' The Green').

Local churches play their part in remembering the more recent mining heritage of the area. Staveley church has a memorial to the miners killed in the Markham Pit Disasters of the 1930s. Over the door at Bolsover church is the resting place for an NUM Bolsover Branch banner. A constantly-burning miner's lamp (run on electricity) provides the sanctuary lamp for the churches at Bolsover, Staveley and Ault Hucknall.

Above: Jack O' The Green, Wingerworth church.

Right: Miner's sanctuary lamp at Ault Hucknall.

8. Chesterfield at the Races

Chesterfield once had its own racecourse at Whittington Moor, but the only tangible traces of its existence now are the street names of Racecourse Road, Racecourse Mount and Stand Road. The Duke of Devonshire (former Lord of the Manor) was a great patron of the racing. Whittington Moor was, as its name suggests, once a moor. As the town grew, it encroached upon this once rural location, necessitating a degree of improvisation when the races were held. An 1894 guidebook to the town marvelled: 'Soon after leaving the town we reach the race-course, and a most extraordinary race-course it is. It is in the form of a circle, and consists for the most part of a green lane hemmed in by houses. The road by which we are travelling passes through its centre, and when it is in use a carpet of tan is laid down in the two places where it crosses the highway ... We shall pass on, only marvelling that anywhere horses should have to run races across a hard high-road.'[27]

In addition to Chesterfield's official racecourse, something that I had seen mentioned a few times in print and online was the 'Donkey Racecourse'. Townsfolk seemed to have fond childhood memories of long unsupervised days playing here in what was once a rural backwater of Chesterfield, before it disappeared under the Loundsley Green estate, which was built to house the migrant workers of the Post Office's AGD department

Racecourse Road, a reminder of Chesterfield's former racecourse.

27 Foster (1894), p. 173

(*see* 'Relocation, Relocation, Relocation') – but no one ever explained the source of the name. I put out an appeal to the members of the 'Old Chesterfield Pics' group on Facebook.

Ann Kretzschmar responded, 'My understanding is that there used to be Donkey Races there in days gone by … It was before my time so I'm just going on hearsay'. Val Garner supported this theory: 'It was what it says: a donkey racecourse long ago when there was nothing but fields right down to Brampton people use to race donkeys and bet on them.'

As with any good folk history worth its weight in salt, there was, however, an alternative theory. Caleb Rush offered this to me: 'I heard a story, I think it was my grandad who told me, before canals and railways everything was transported by packhorse, including salt. These packhorses came all the way from Cheshire, where the salt is. On the last leg, at Holmebrook, they would put on a bit of a spurt, hence "Donkey Racecourse". This also explains the salt in Saltergate. I don't know how true that story is, but that's what I heard.' Barry Stancill had some further information to corroborate this theory: 'as you go under Loundsley Green Road towards Linacre where the path runs now there were flagstones laid all the way to Linacre. When I asked the old timers they said it was a pack track, the name "Donkey Racecourse" came about because the donkeys could walk faster with the ground being level. I don't know if it's true or not'.

In the manuscript of an intended history of Derbyshire, the seventeenth-century writer Philip Kinder made reference to an unusual sport enjoyed by the locals:

> Their exercise for the greate part, is the Gymnopaidia, or naked boy, an ould recreation among the Greeks; with this, in foote races, you shall have in a winter's day, the earth all crusted over with ice, two antagonists, stark naked, runn a foote-race for two or three miles, with many hundred spectators, and the betts very small.

Loundsley Green – site of the 'Donkey Racecourse'.

We have a fuller account of the naked boy races from the writings of a Mr Forrest,[28] who happened across them by chance while riding from Chesterfield to Worksop in the winter of 1755. Upon entering Staveley (or as he spelt it, 'Staverly'), Mr Forrest was surprised to see huge crowds forming, clearly in anticipation of an impending event. Upon making enquiries, he was informed that 'the Naked Boys' were about to race a distance of 3 miles. Forrest is 'astounded', given that 'the earth was encrusted with a thin ice and the northerly wind cut to the marrow.' His interest sufficiently piqued, he dismounts his horse and determines to see the race himself, joining the crowd of hundreds of men and women 'of all ages', noting the many bets being placed on the outcome of the race.

The race was contested by four youths, all aged around sixteen years and of similar height (nearly 6 foot). Forrest observed that despite their state of nudity, the intense cold did not seem to bother them. The course of the race was a 3-mile circular route taking the runners round the village of Brimington and back to Staveley. The racers managed to complete the course in a mere twenty minutes with the result being an extremely close call, won 'by one stride only'.

Forrest established that a similar race was to be run the following day at Whitwell, and, having clearly developed a thirst for naked boy racing, consequently cancelled his travel plans and holed himself up at the George Inn, the starting point for the second race. This time around a circular course of the village 2 miles' distance was run, the entire length of the route lined by cheering crowds. Following freezing temperatures overnight, the going at Whitwell is similarly wintery to the day before at Staveley, but this has not deterred spectators: Forrest notes that an even greater number of people have turned up to spectate at Whitwell, travelling in from Sheffield, Derby, Mansfield, Chesterfield and Worksop. For this second day of racing there were six runners, with the previous day's winner, Flaxey Rotherham, a Whitwell native, again taking part; Mr. Forrest says it was plain to see that he was 'the village idol'. He attempts to place a bet on him to win, but is unsuccessful in doing so.

For the second day in a row, Flaxey romped home, although this time on home turf 'six strides ahead of his nearest rival', to near deafening cheering from the crowd. The losing boys appear to have been good sports as they seized Flaxey up and hoisting him to shoulder height proceeded to paraded him victoriously around the village.

Following the race, Forrest again marvels that the racers seem wholly unaffected by the cold: they remained fully nude ('not even a cloak was offered them') for the duration of this parade, which lasted around an hour, during which time he reports their bodies were steaming.

Finally the participants retired to the local inn, where in a kind of Naked Boy Racing pit stop, they were rubbed down vigorously with coarse hop-sacking by their helpers, and given a large jug of hot mulled ale each to drink. Only after this ritual did the racers get dressed, and they were then brought a hearty meal of two large oat cakes 'thickly spread with honey and topped with best Derbyshire cheese', followed by large portions of best tenderised bull's beef, apple pies and further helpings of mulled ale.

Following the meal the company at the pub descended into much communal singing and joking. Mr Forrest ends up getting so swept along with proceedings that he ends

28 Forrest-Lowe (1966)

Staveley – former hotbed of Naked Boy Racing.

up having to spend an extra night at the inn, 'before commencing my journey forth to Worksop, where I arrived two days late for my business on hand, but so great had been my pleasure that I vexed little'.

Mr Forrest's descendent, Mary Forrest-Lowe, shared her relative's report on the races in a *Derbyshire Countryside* article in 1961, and conducted some additional research, managing to glean some more information about Whitwell's young naked hero. It transpires that 'Flaxey' was a nickname stemming from his day job in the family firm, a flax mill, his real name being John. His sideline as a naked athlete proved a lucrative supplement, as he is recorded as having netted a prize of £25 for winning a race in the High Peak – according to the Bank of England's online 'Inflation Calculator', this sum would equate to a whopping £5,188.50 in 2016 terms (the latest year it currently goes up to). Forrest-Lowe also unearthed references to a few of Flaxey's rivals, with a Clark of Chesterfield beating Flaxey at a race run at Buxton in 1753, and the pair of them narrowly being beaten by a Castleton youth with the surname of Richardson at a Whitwell race in the same year.

The Naked Boy races were denounced by the clergy and were finally officially banned by the High Sheriff of Derbyshire in 1756 – the year after Mr Forrest's eyewitness account. The threat of heavy penalties were subsequently imposed on those either stripping off to take part, or promoting the races. The authorities also attempted to erase this once popular Derbyshire pastime by destroying prints and old paintings depicting the racing. If it were not for the passing reference from Kinder and the fuller account left by Mr Forrest, this once-popular pursuit would have vanished from the annals of history.

Although naked races have died out in their former stronghold of North Derbyshire, a couple of music festivals around the globe gamely still fly the flag for the sport. The *Nøgenløb* (Naked Race) is run annually by music fans (of both sexes) at Denmark's Roskilde Festival, whilst the 'Meredith Gift' is the name of a race run by nude participants at Australia's Meredith Music Festival (with separate races for male and female runners). While not really staged as a race, the World Naked Bike Ride, where cyclists ride in various states of undress as a protest against dependency on oil-powered transport while promoting cyclist safety and positive body image, is held in locations around the world. A ride was mooted for Chesterfield in both 2015 and 2016, but didn't end up getting off the ground either year, and was subsequently put on ice owing to lack of interest.

Wherever there is racing, be it conducted by horses, dogs or naked boys, there is going to be betting – and not always legal betting at that. Chesterfield has the curious distinction of being the first town in England to use surveillance film footage as evidence in a British courtroom, and it was used to bring down a gang of illegal street bookies in 1935. PC Saunders of Chesterfield Borough Police secreted himself and a movie camera in the first floor of a building overlooking the Market Place, from where he captured the activities of the bookmakers over the course of a week.

To add an extremely surreal touch to the proceedings, in a perfect illustration of the infinite strangeness and unpredictability of life, at one point this historic footage is gatecrashed by a troop of elephants ambling into the frame and making their way across the marketplace (they happened to be performing in a circus that was visiting town at the time of PC Saunders' surveillance). The film can be watched under the title 'Evidence' on the BFI's Map of Britain on Film.

9. Broaden Your Mind

Chesterfield has had an impressive array of facilities and organisations over the years for its inhabitants to expand their minds and indulge their interests. An early regional branch of the Worker's Educational Association (formed in 1903) was opened in the town in 1908, and they still offer courses in a wide range of subjects for working adults from their offices on Stand Road, aiming for an informal yet stimulating approach.

Chesterfield had a 'modest' subscription library as early as 1791, with the town's first public library opening in 1880 in the Stephenson Memorial Hall in what nowadays forms the premises of the museum. The current library on New Beetwell Street (to which I had many happy Saturday afternoon trips as a child) opened in 1985 as part of The Pavements development.

A more unusual facility is Chesterfield's very own observatory, located at the end of Hastings Close, Newbold, an unassuming cul-de-sac. Built over a three-year period in the late 1950s on former farmland, this was largely the vision of Horace Barnett.

Worker's Educational Association offices, Stand Road.

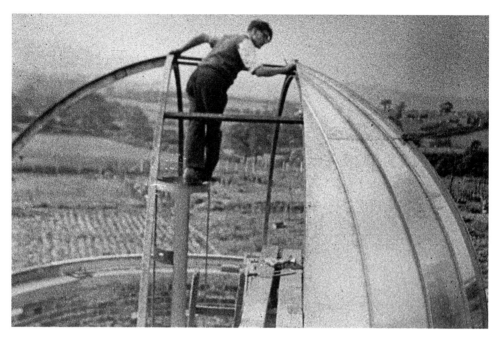

Building the Horace Barnett observatory, late 1950s. (With kind permission of Chesterfield Astronomical Society)

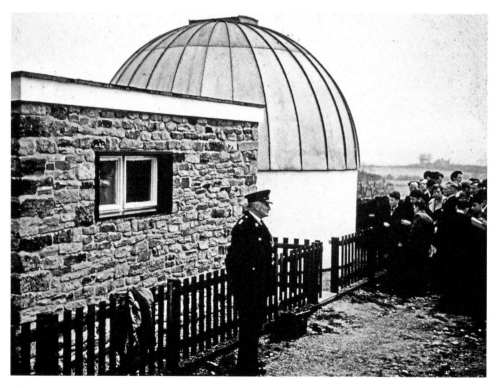

The opening of the observatory, 1960. (With kind permission of Chesterfield Astronomical Society)

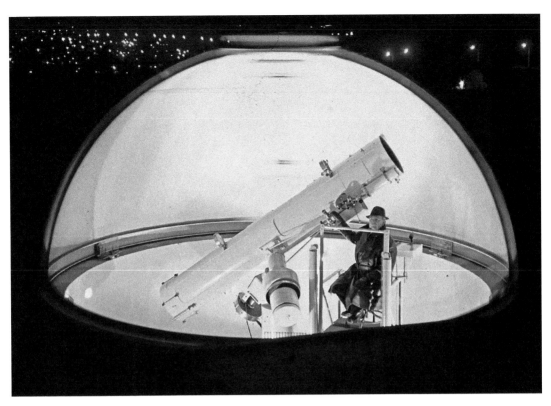

Look to the skies. (With kind permission of Chesterfield Astronomical Society)

Barnett conducted much of the building work and went around his work colleagues scraping together modest contributions towards the building costs. It was completed in 1960; by the end of that decade, man was walking on the moon, but the Horace Barnett Observatory is as remarkable an achievement in its own way. Many at the time thought it couldn't be done, and the observatory builders earned the nickname 'The Newbold Nutters' from locals! Chesterfield Astronomical Society (who the facility belongs to) are anything but possessive with their resource, as they hold open evenings every Friday inviting the curious to peep through their telescope, and are working on getting a video feed from the scope through to their lecture room. Unfortunately it was too cloudy to use the telescope when my stargazing friend Dean and I visited, but we were made to feel extremely welcome.

In 1902, a group of curious souls banded together to form the East Derbyshire Field Club. The founders of the club were members of the East Derbyshire Teachers Association, although anyone who shared an interest in the group's focus of local history, geology, and natural sciences was able to join. Members enjoyed a packed programme of rambles throughout the summer, with the collecting, mounting and labelling of specimens during these walks encouraged to provide teaching material. When the nights drew in, there were indoor lectures and talks during the winter months. These included 'Travels of a Scrap of Paper' and 'The Anatomy of the Common Slug'.

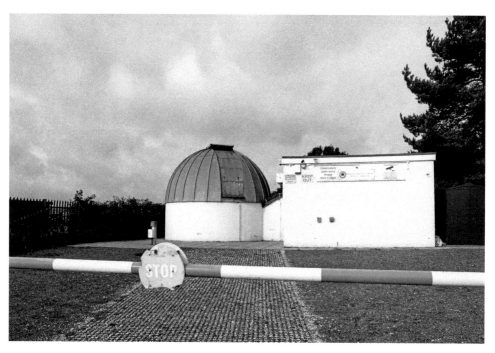

A modern-day view of the observatory.

The observatory's lecture room.

Transactions of the East Derbyshire Field Club. (With kind permission of North East Derbyshire Field Club)

Off they tramped into the areas around Chesterfield (Staveley, Doe Lea, Hardwick, Barlborough, Sheepbridge, Holymoorside); the well-known delights of the Peak (Matlock, Birchover, Lathkill Dale); and forays into lesser-known areas of mid- and south Derbyshire (Fritchley, South Wingfield, Morton, Crich). They travelled by train to now-vanished Derbyshire stations (Wingfield, Scarcliffe, Renishaw, Blackwell, Westhouses, Stretton) as well as by hired motor charabanc and took advantage of the very early days of public bus routes. They wangled their way into the grounds of the area's mansions – then rarely open to the public – to snoop around, visited the local telephone exchange to see how it worked and went down coal mines. The club is still going to this day (meetings were suspended around the time of the onset of the Second World War, but the club was revived as the North East Derbyshire Field Club in 1949), with a similar programme of lectures and walks (although 'nothing like what they used to get up to, they used to walk miles', a current member told me).

The club's annual transactions are full of wonderful details, such as 'Mr Stone's paper on Grasses was read to an interested audience reclining under trees in Scarcliffe Park' in 1912. On a visit to the ruined Wingfield Manor in 1918 a paper on the history of the manor house was read to the assembled members in the crypt, and at the same meeting 'War conditions led to a revision of the customary arrangements, members bringing their own

tea, sugar and provisions, which were thrown into a common stock, the "Field Club Blend" of tea being voted a distinct success – so much so that the practice was repeated at most of the subsequent outings.'[29]

While the activities of the club frequently seem to hark back to a more innocent age, there are occasions where reports from the transactions reveal how society has changed since their inception. Modern-day members of the club would be far more likely to be reporting Mr. C. B. Chambers, of The Gables, Holmewood, to the local Wildlife Crime Officer, rather than thanking him and his wife for their kindness and hospitality during the group's visit to their home in 1920 to view CB's 'varied and extensive' collection of British birds' eggs, described as 'probably the most extensive in the county'. Likewise, if a speaker turned up to a Field Club meeting nowadays to give a talk on 'Some Derbyshire Birds', as Reuben Fletcher did in 1905, and began recommending to members that goldfinches and linnets made ideal pets, eyebrows would probably be raised.

Fletcher, the headmaster of Stainsby primary school, further detailed his bird-kidnapping activities in a 1923 talk, 'Birds and their Ways'. He reported to the group on a common country practice of the time:

Rural boys often have sparrow hunts on winter evenings. Stacks of straw, corn, or hay are happy hunting grounds. A small-meshed net is put round the stack; the stack is then beaten with sticks and out fly the birds to be caught in the net. A stack in a remote part will often furnish many other varieties of birds beside sparrows – birds that have crept in for warmth in severe weather. I have seen chaffinches, wrens, yellow-hammers, etc. caught in these expeditions.[30]

We can imagine that a 1920s headmaster in a mining district would be a tough discipline master, and that as a bird-lover Fletcher might have had something to say when catching local lads poaching wild birds in this manner – had we not had the spoiler alert from his earlier presentation. Fletcher goes on to inform us that in fact he acquired a yellowhammer caught by the rustic youth in this manner for his aviary of British birds that he kept in the grounds of the schoolhouse. Described as the finest yellowhammer he had ever owned and 'nicer than any canary in his markings', to cap off his capture and subsequent imprisonment this unfortunate songster met his demise when an escaped pig went on the rampage in the aviary! Mr Fletcher recommended bullfinches as good pets during this talk and revealed they could learn to pipe a tune if trained young (he had kept several in his aviary), and revealed that he had been practicing bird eugenics by interbreeding linnets with canaries.

Brampton formerly had a museum opened in a large eighteenth-century house on Chatsworth Road by Revd Magens Mello, the rector of St Thomas' Church. In addition to his day job, Mello was a notable archaeologist who had conducted excavations at Cresswell Crags on the Derbyshire-Nottinghamshire border and there discovered along

29 *Transactions EDFC*, 1918–1921, p. 2

30 *Transactions EDFC*, 1923, p. 55

with William Boyd Dawkins the first piece of portable cave art to be found in Britain (an animal rib with an engraving of a horse on it). Mello exhibited many of his collections at the Chatsworth Road premises, as well as giving lectures and 'penny readings' for working people. Other features of the facility included a billiards hall and a lending library. The building was later purchased by the Borough Council and demolished in 1932 for street improvement purposes.

Another short-lived museum facility for the benefit of townspeople existed at Tapton House, former home of George Stephenson. After his death it had passed to the Markham family until 1925, when Charles Paxton Markham donated the estate to the borough. A rudimentary museum was housed here until 1931, when it became a school.

'Changing Face of Chesterfield', a 1963 *Derbyshire Countryside* article focusing on the forthcoming transfer of the Post Office AGD workers to the town (*see* 'Relocation, Relocation, Relocation'), tried to assuage those soon to arrive from London that Chesterfield wasn't a complete cultural wasteland – although did observe that the town would benefit from art gallery and museum facilities. It took Chesterfield another thirty years to get that facility, which opened in 1994 at the Stephenson Memorial Hall in the former premises of the library, which had transferred to New Beetwell Street the previous decade. (The Memorial Hall as first opened originally contained an 'Engineers Museum' along with the Mechanics Institute.) 'It's always been a place where people can exchange ideas and learn a bit,' the museum's collections officer reminds a small group of us who have assembled at the museum one Saturday afternoon. In common with most museums, Chesterfield can only display a fraction of its collections at any one time, with the majority being kept in storage for safekeeping. The museum run monthly 'Behind the Scenes' tours of its storeroom however, so I am here along with a few other curious souls to have a snoop. In addition to the onsite store at the museum we are visiting, there are also two offsite stores housing the archaeology collections and larger objects, as well as a collection from Robinson's firm.

The surrealist artists of the 1920s used to visit flea markets as they found inspiration for their works in the odd and unexpected juxtaposition of objects on the stalls. For the same reason, they would have greatly enjoyed Chesterfield Museum storage facility. An antique harp with most of its strings missing is cosying up against a slightly terrifying looking 'Hair Waiving Machine' from a vintage era ladies' hair salon. While to the untrained eye this seems like a random assortment of objects – a whole town's equivalent of the stuff shoved up the loft – the reality is that these objects are highly organised. Each item that is accepted into the museum collection is given its own unique accessions number, added to the item in such a way as not to permanently scar it: sewn into fabrics, written lightly in pencil on paper items and photographs, and for other objects a thin layer of varnish is applied in an unobtrusive place, the accession number inked on, and then another layer of varnish applied on top, meaning it can all be later removed without leaving trace if necessary. The accessions number is noted down in a series of ledgers with as much information as to provenance as possible; these ledgers are then kept in a fireproof safe with a photocopied version stored offsite.

As well as items on shelving units, surrounding us are hundreds of stacked boxes, all labelled with their contents: 'Items Relating to Violet Markham'; 'Hilda Taylor's

Above, left and opposite page: Behind the scenes at the museum. (With kind permission of Chesterfield Museum Service, Chesterfield Borough Council)

Hairdressing Items'; 'Baby's Gas Mask'; 'Bobbins For Sock Machine'; 'Miner's Helmets and Goggles'. The collection encompasses roughly 35,000 social history items, and in a worthy initiative some are collected together in 'memory boxes' and taken to local care homes to stimulate reminiscences and conversation with dementia patients.

The delicate balancing act for the museum staff is making the collection accessible to townsfolk and visitors while also making sure nothing gets damaged. The storage facilities are all carefully controlled environments. The lights are kept switched off unless someone is visiting or working in there. We are shown a pair of turquoise ladies' trainers to illustrate the damaging effects of light – one shoe had been displayed in a shop window, and the colour had faded significantly by comparison with its twin, which had been kept in the storeroom of the shoe shop. 'The other thing we're looking out for is what's eating the collection' we are told – moths, silverfish, and carpet beetles being the main culprits.

10. Relocation, Relocation, Relocation

'When Chesterfield was gorse and broom, Leash Fen was a market town; Now Chesterfield's a market town, Leash Fen is but gorse and broom.'

This old Derbyshire saying is unlikely to win any poetry prizes, but it is illustrative of the fact that the towns, villages and cities in which we all live are built on slightly less solid foundations than we might care to think. Settlements can either become abandoned, or up sticks and relocate, for a variety of reasons. This chapter explores some local examples, as well as looking at occurrences of mass migration into the area that happened within living memory.

The area named on maps as Leash Fen is now a rather desolate, boggy spot on the moors between Chesterfield and Baslow. Legend tells of it being the location of a formerly prosperous town that one day without warning sank into the earth, the incident being witnessed by a solitary person stood nearby on higher ground. When drainage ditches were cut across the moorland in the 1830s, fragments of earthenware pottery were found along with primitive coins and pieces of oak, which appeared to have been cut by some sort of tool and may have been poles that once supported housing, all of which lend a degree of credibility to the yarn.

Sheldon (1986) records that the area became recolonised from 1916 onwards by large quantities of black-headed gulls. This caused friction with the resident population of lapwings, and many skirmishes between the two species took place out on the moors. The gulls began to nest around the marshy pools as usual in the spring of 1941, but following the terrible Sheffield Blitz of December the previous year, a number of unexploded bombs, which had been found among the shattered streets during the subsequent clear-up operations, were brought out to Leash Fen to detonate, as it was one of the closest uninhabited areas to the city. The resulting loud explosions scared away the nesting gulls, and according to Sheldon at the time he was writing (the early 1970s, his history of the area being published posthumously the following decade), they had not returned.

Heath lies 4 and a half miles distant from the Crooked Spire as the crow flies. The village appears to have been settled by Danish invaders in the late 800s, and at the time of the Domesday Book in 1086 two separate hamlets of Lunt and Le Hethe are recorded in the area of present-day Heath. Scandinavian settlers were apparently very active in this area to the south-east of Chesterfield, with nearby surviving place names ending in '-by' (Stainsby), '-toft' (Hardstoft), '-wick' (Hardwick) and '-thorpe' (Williamthorpe) all characteristic of the old Scandinavian languages. The Viking invaders also left their influence on the accent and dialect of North Derbyshire, the language they brought with them from faraway lands still having bearing over a thousand years down the line on how people from this neck of the woods speak. Some linguistic scholars even think that that most innocuous and commonplace Chesterfield greeting 'Ay up' may originally

derive from the Old Norse 'Se upp', meaning 'Look up' or 'Watch out'! Lunt stems from the Danish 'lund' meaning a grove of trees, and this is a common element that occurs at the end of place names throughout the Scandinavian countries of Denmark, Sweden and Norway.

A review on the Master Mummers website of the book *Masks and Mumming in the Nordic Area* observes the similarities between the Derby Tup and Scandinavian *Julebukk* custom, where a goat's head on a pole is operated from under a sack by a performer and taken from house to house at Christmas time, and a short play or song performed. Wild speculation, but could the Owd Tup have been introduced to the area by the Viking invaders who settled the area around Heath in the ninth century?

The Heath (from the old Danish 'Hede' meaning 'heath of waste land') was originally the barren area of waste and common on the higher ground to the west of the original settlement of Lunt. Lunt mutated over the years to Lound, then 'Lounde alias Heathe' before eventually settling on the Heath that we know today. This change of name is mirrored in the way the settled area gradually moved from Lunt to the present-day Heath.

As a result of the location shift, in the mid-nineteenth century it was decreed that one of the focal points of the village, its church, must up sticks and move to the area of former wasteland where most Heath residents by now found themselves living. One tangible reminder of Lunt remains, however, and thousands of people must whizz past it in close proximity every day without realising it is there. Heath 'Old Church' is the last

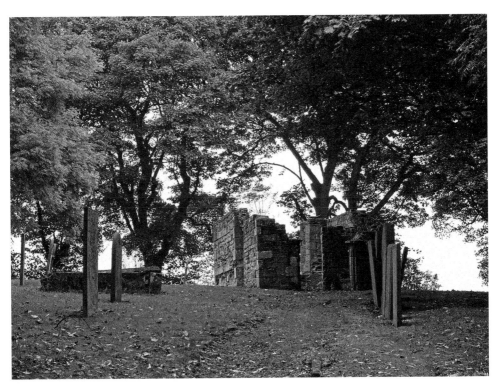

The remains of the former church of Lunt.

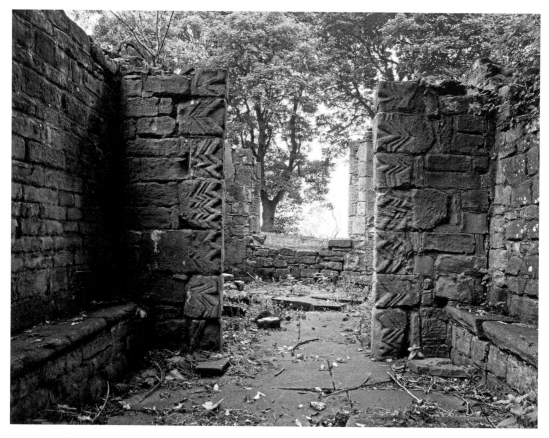

Incised stonework at the ruined Lunt church.

remaining building from the former dominant settlement, and the ruins cannot be dated exactly; there is a definite record of the church being here by 1307, but it may have been constructed up to 150 years earlier.

The remains of Lunt's church can be found by taking the left turn-off just before entering the M1 at Junction 29, behind the house 'Fair View' (given that it overlooks the M1, either the name predates the building of the UK's first motorway, or the original owner had a sense of humour. As a very poor traveller as a child prone to severe travel sickness, this house formed something of an important landmark for me on the return drive back from childhood holidays down in Devon, signifying that the long and arduous car journey was almost over. It was formerly the home of Mo Moreland AKA 'The Mighty Atom', leader of Les Dawson's larger-than-life (i.e. fat) TV dance troupe The Roly-Polys).

All that now remains of the church is part of the porch, with medieval incised stonework still visible, and several gravestones with dates up to the mid-nineteenth century, now finding themselves rather forlornly marooned. Rest in peace? Little chance of that for these poor souls, given the incessant thrum from the M1 motorway (located just over the hedge) most hours of day and night. But at least someone still cares about them – the site had been recently mowed at the time of our visit. Elsewhere, however, nature was

Gravestones reclaimed by nature at Lunt church.

reclaiming the site: in one instance a tree appeared to be in the process of swallowing a gravestone that was propped up against it.

Following the shattering years of the First World War and subsequent Great Depression, getting back to the land was increasingly viewed as a panacea. In 1920, Derbyshire County Council bought a number of farms including Swatchwick Farm at the carving up and sale of the Hunloke estate at Wingerworth for tenancy by ex-servicemen who had served in the recent war but had not managed to successfully settle back into post-war life. Seven miles from Chesterfield, in the rural landscape outside Bolsover, the remains of a little-known and extraordinary social experiment can be found, in the shape of the Oxcroft Estate, created to provide unemployed men and their families the opportunity to work and earn money.

Using land purchased from the Duke of Devonshire, forty smallholdings with on average 5 acres of land were laid out, arranged around pairs of semi-detached three-bedroom houses. Oxcroft is one of only two land settlements in the UK that were instigated by a county council. Given that it was located in an area dominated by mining, one would expect there to be plenty of out-of-work colliers to hand. In practice, the makeup of the Oxcroft tenants was quite cosmopolitan: there were ex-colliers from Durham and the West Riding, ex-steel workers from Tyneside and South Wales, and even a Russian.

The Oxcroft Estate.

We have a valuable record of life on the settlement in the shape of Fred Kitchen's 1947 book *Settlers in England*. Kitchen was born 9 miles away at Edwinstowe in Nottinghamshire and grew up on a tied farm on the Sandbeck Estate. Following the death of his father when Fred was still a youth, he travelled around the country taking on a number of farming and labouring jobs. He had little formal education, but was a voracious reader and took WEA classes at Worksop where he was encouraged to write by his tutor. His first and best-known book, *Brother To The Ox* (1939), had been published by the time he arrived at Oxcroft.

Kitchen first viewed the settlement in early 1942, and wasn't initially hugely impressed given that it was covered in a foot of snow at the time. However, he made the decision to apply for a vacant smallholding and was accepted out of the ninety other applicants, moving to Oxcroft at Easter of that year. By the time of his tenure, the ethos of the settlement had changed owing to the fact that Britain was by now at war. Tenants for the estate now had to have prior experience of farming (as Kitchen had) as produce from the estate was contributing towards Britain's food rations.

After leaving the Land Settlement, Kitchen settled in Bolsover, moving to a house on Mooracre Lane. He carried on writing but also worked as a gardener for three local

Settlers in England: Fred Kitchen's record of life at Oxcroft.

schools. He regularly attended local Methodist churches and preached himself for over a decade. He died aged seventy-eight in 1969 at Chesterfield Royal Hospital, and his ashes were interred at Oxcroft Lane Cemetery. There is a movement among some locals to instigate a memorial bench at Bolsover Library to widen awareness of Kitchen's writings and his local connections.

The Land Settlement came to the attention of filmmaker Ian Nesbitt in passing during conversation with local historian Bernard Haigh. Nesbitt's interest was piqued, particularly when he discovered there was very little information regarding its history in the public realm. Through Bernard, Ian was introduced to some of the Oxcroft residents, several of whom had been lifelong occupants since they arrived as children of the original settlers in the 1930s. Ian's 2015 film, titled *Settlers In England* after Kitchen's book, is a wonderfully evocative and meditative exploration of life up at Oxcroft, Ian remarking 'I believe the largely untold story of the wider LSA is an important one to shine a light on that has a resonance for us in these times of anxiety around food production, when we are so completely reliant on the whim of big supermarkets to provide for us, and retain so little connection with the land.'

Polytunnel greenhouses at the Oxcroft Estate.

The settlement today remains a unique place, pairs of semi-detached houses spaced out at large intervals owing to the amount of land ascribed to each property. The functional uniformity of the 1930s houses, as elegantly rendered in the black-and-white line drawings by E. J. Browne, which illustrate *Settlers In England*, has given way over the years to individual customisation. The houses have been reroofed and repainted, the small paned windows replaced by double-glazing, some have trampolines and children's trikes in the front gardens and ostentatiously spiky front gates to keep snooping historians at arm's length. A handful of Oxcroft residents are still using the houses and land productively as they were originally indented, including Gaz and Laurenne Hopkins who moved to Oxcroft in 2016 to set up their organic vegan smallholding Happy Roots Farm. They sell their Oxcroft-grown produce from their roadside honesty stall and by making weekly deliveries to the surrounding area in their electric car.

A much larger-scale relocation of workers to Chesterfield occurred with the moving of the GPO's Accounts General Department (AGD) and Pensions Administration department to Chesterfield in the early 1960s. Following the Second World War and the Blitz raids on the capital, the government had come to realise that having all its administrative departments concentrated in London left the country vulnerable in the event of a future conflict. The move was a huge operation as somewhere between 2,000 and 3,000 Post

Roadside farm stall at the Oxcroft Estate.

Office workers and their families were relocated to Chesterfield from London, Kent and Harrogate. Early retirement was offered to the staff by the Post Office prior to the move, with some towards the end of their working life taking up the offer, but the majority of the staff that came to Chesterfield made the move voluntarily. According to a 1962 *Derbyshire Countryside* article, a booklet, *Moving To Chesterfield?*, was issued to those taking the plunge to culturally prepare them for life in North East Derbyshire – I am sorry to report that I have not been successful in tracking a copy down. The move required a huge investment in infrastructure to accommodate the new influx of workers, with the building of extra roads, sewers, schools and churches all having to be put in place before the displaced workers arrived. The majority of the GPO staff and their families were housed at a newly built estate at Loundsley Green – formerly the rural fringe of town and site of the 'Donkey Racecourse'.

The new AGD offices at West Bars, Chetwynd House, were opened in 1963, but had a relatively short lifespan, being demolished owing to structural problems in 1997 and replaced with more modern premises, the only remaining building from the 1960s being the Sorting Office.

To celebrate the bright new partnership between the Post Office and Chesterfield, *Rosewall*, a modern art sculpture by celebrated sculptress Barbara Hepworth, was

Housing at Loundsley Green.

1960s Sorting Office, West Bars.

Return to Sender: Curved Reclining Form (Rosewall). (Barbara Hepworth, 1960–62)

commissioned using public money and sited outside Chetwynd House. The sculpture was loaned to the Yorkshire Sculpture Park in 2003 as part of a retrospective marking the centenary of Hepworth's birth. It subsequently turned up in an auction listing at Bonhams. After a public outcry, it was bought for £500,000 by the Borough Council with assistance from the Art Fund, and finally returned to Chesterfield in 2009.

To conclude this section, we all know why the chicken crossed the road, but why did the village cross the road? Because dangerous emissions of methane gas were discovered under the houses following the closure of the local colliery. I agree, as punchlines go, it's not as snappy as the chicken one.

The pages of history and geography books are littered with numerous settlements that either vanished or relocated (Peter Naylor in his *The Lost Villages of Derbyshire* explores a range of reasons for why this occurred from climate change, mass genocide, pestilence, clearances by monasteries to facilitate sheep farming, expanding urban sprawl following the Industrial Revolution and the whims of local aristocrats). But it is rare indeed for a whole community to up sticks at as late a date as 1988, as Arkwright Town did.

When I was a child in the 1980s we used to drive over to my auntie's house in Bolsover most weekends and on the return trip to South Darley we used to pass through Arkwright.

It was always on the left-hand side of the car, but by the mid-1990s had switched to being on the right-hand side.

An Arkwright native, Charles Dickens (no, not *that* Charles Dickens), remembered in *Aspects of Chesterfield* (2002) a close-knit community of 152 houses, where wayward behaviour was regulated by virtue of the fact that everybody knew each other. Amenities included a pub, Miners' Welfare, chip shop, school, chapel and allotments. The builders of the replacement Arkwright strove to replicate this sense of a close community, with winding streets of the new estate paying homage to the former street names from the old village.

Arkwright Town mark two.

Bibliography

Addy, S. O., *Household Tales with Other Traditional Remains: Collected in the Counties of York, Lincoln, Derby & Nottingham* (London: David Nutt, 1895)

Aldous, Tony, *New Shopping in Historic Towns: The Chesterfield Story* (London: English Heritage, 1990)

Anon, *Pages from the History of Heath: A Miscellany* (Heath: All Saints, 1994)

Bestall, *History of Chesterfield Vol 1: Early & Medieval Chesterfield* (Chesterfield: Borough of Chesterfield, 1974)

Bower, Alan, *Chesterfield and North-East Derbyshire on Old Postcards* (Nottingham: Reflections of a Bygone Age, n.d.)

Cocker, Jarvis, *Mother, Brother, Lover* (London: Faber, 2011)

Coleman, Stanley Jackson, *Treasury of Folklore 32: Legendary Lore of Derbyshire* (Douglas: Isle of Man: Folklore Academy, 1954)

Court, Arthur, *Staveley, My Native Town: Some Historical Notes of the Parish* (Sheffield: J. W. Northend Ltd, 1946)

Davis, Brian, *Chesterfield Through Time* (Stroud: Amberley Publishing, 2009)

Dunstan, John, *Old Derbyshire Desserts: The Traditional Cakes, Puddings and Biscuits of Derbyshire* (www.lulu.com, 2008)

Eyre, William J., *Strange North-East Derbyshire* (Dronfield: William J. Eyre, 2016)

Foster, Albert J., *Round About the Crooked Spire* (London: Chapman and Hall Ltd, 1894)

Hall, George, *The History of Chesterfield: With Particulars of the Hamlets Contiguous To the Town, & Descriptive Accounts of Chatsworth, Hardwick & Bolsover Castle* (Chesterfield: Thomas Ford, 1839)

Innes-Smith, Robert (Ed.), *Derbyshire Guide* (Derby: Derbyshire Countryside Ltd, 1982)

Keeling, Jeremy, *Jeremy & Amy* (London: Short Books, 2011)

Kitchen, Fred, *Settlers in England* (London: J. M. Dent & Sons Ltd, 1947)

Midland Railway Co., *An Illustrated Guide to Chesterfield & Its Surroundings* (Facsimile Reprint) (Chesterfield : Alan Hill, 1988)

Milner, J. E., *The Ancient Church & Parish of Ault Hucknall* (Heath: All Saints Church, 1994)

Naylor, Peter, *Lost Villages of Derbyshire* (Darley Dale: Happy Walking International (Derbyshire Heritage Series), 1997)

Naylor, Peter & Porter, Lindsey, *Well Dressing* (Ashbourne: Landmark Publishing, 2002)

Pendleton, John & Jacques, William, *Modern Chesterfield: Its History, Legends, and Progress* (Chesterfield: Derbyshire Courier, 1903)

Pilkington, James, *A View of the Present State of Derbyshire* (Derby: Drewry, 1789)

Porteous, Crichton, *The Beauty and Mystery of Well-dressing* (Derby: Pilgrim Press, 1949)

Sadler, Geoffrey (Ed.), *Aspects of Chesterfield* (Barnsley: Wharncliffe Books, 2002)

Sadler, Geoff, *Chesterfield: History & Guide* (Stroud: Tempus, 2001)

Sheldon, John, *A Short History of Baslow and Bubnell* (Baslow: S. M. Evans, 1986)

Smith, Mike, *Picture the Past: Chesterfield* (Derby: The Derby Books Publishing Company Ltd, 2010)

Thompson, Roy and Lilley, John, *Chesterfield in Old Picture Postcards* (Zaltbommel (Netherlands): European Library, 1989)

Tongue, Ruth, *Forgotten Folk Tales of the English Counties* (London: Routledge & Kegan Paul, 1970)

Addy, S. O., 'Mumming and Guising in Derbyshire', *Derbyshire Archaeological Journal* Vol. 29 (1907), pp. 31–42

Anon, 'Changing Face of Chesterfield', *Derbyshire Countryside* Vol. 28, No. 4 (June 1963), pp. 43–47

Anon, 'Looking at the Stars', *Derbyshire Countryside* Vol. 25, No. 5 (August 1960), p. 27

Forrest-Lowe, M., 'The Naked Boys of Derbyshire', *Derbyshire Countryside* Vol. 31, No. 1 (January 1966), pp. 40–41

Murphy, Janet, 'Holidays at Home 1944', *The Cestrefeld Journal* Issue No. 4 (September 2015), pp. 10–12

Russell, Ian, 'A Survey of Traditional Drama in North East Derbyshire 1970–78', *Folk Music Journal* Vol. 3 Number 5 (1979), pp. 399–478

Shipley, William J., 'Folk Dancing In Derbyshire', *Derbyshire Countryside* Vol. 1 No. 4 (October 1931), p. 64

Woollven, Val, 'Linacre', S40 Issue No. 51 (March 2014)

Brimington and Tapton Miscellany 2, 4, 6

Chesterfield Shopping Festival Programmes 1910, 1914, 1950

In Town, Chesterfield's Monthly Entertainment and Shopping Guide 1952–54

Notts. & Derbyshire Notes and Queries, Vols. I–VI (1892–98)

Transactions of the East Derbyshire Field Club, 1905–31

Local newspapers: various, as referenced

Dave Bathe Collection & Charlotte Norman Collection, University of Sheffield Library Special Collections

Pulp, *We Love Life*

Pound A Bag by Ian Hoare (A Tribute To A Chesterfield Legend), https://www.youtube.com/watch?v=PAZKC4q_2N8

Settlers in England (dir. Ian Nesbitt, 2015), https://vimeo.com/121122270

Evidence (1935), https://player.bfi.org.uk/free/film/watch-evidence-1935-online

http://www.chesterfield-as.org.uk

http://www.derbyshireheritage.co.uk

www.welldressing.com

http://www.engineering-timelines.com/who/Stephenson_G/stephensonGeorge9.asp
http://www.english-heritage.org.uk/visit/places/bolsover-castle/
http://www.iannesbitt.co.uk/index.php?/short-films/settlers-in-england/
http://www.linacre.ox.ac.uk/about-linacre/college-history/thomas-linacre
http://www.mastermummers.org/articles/Review-Masks-and-Mumming.htm
http://www.northern-tea.com/about/northern_tea_history.asp
http://www.royalcentral.co.uk/royaltyinthemedia/chesterfields-tribute-to-diana-attracts-theattention-
http://www.s40local.co.uk/chesterfields-shopping-festivals/
http://www.theguardian.com/books/2013/dec/11/norfolk-norwich-library-most-populartop-
https://www.facebook.com/groups/265947033568563/ – Old Bolsover Pics
https://www.facebook.com/groups/oldchesterfieldpics/
https://www.victoriacountyhistory.ac.uk/explore/items/oxcroft-settlement-of-the-worlds-media-88369
https://www.weachesterfield.com/

Acknowledgements

Maria Barnes, Aleah Bates, Pat Bradley, Michael Broomhead, Councillor John Burrows, Mark Eustace, Rachel Fannen, Val Garner, Ruairidh Greig, Ian Hoare, Dean Honer, Laurenne and Gaz Hopkins, Jean Kendal, Ann Kretzschmar, Beryl Malcolm, Brenda Moseley, Ian Nesbitt, Tom J. Newell, Shirley Niblock, Scott Nicholas, North East Derbyshire Field Club, Ross Parish, Gill and Harry Perkins, James Pogson, Reverend Jonathan Poston, Philip Riden, Janet Robinson, John Roper, Caleb Rush, Ian Russell, Keith Sanderson, Philip Schofield, Dennis Skinner MP, Maria Smith, Barry Stancill, Martin Thacker MBE, Martin, Karen and Joe Voy.

The staff of Chesterfield Library, the Derbyshire Record Office and Special Collections staff at the University of Sheffield Western Bank Library – all wonderful resources.

Ian Hoare for permission to quote lyrics from his song 'Pound a Bag'.

Chesterfield Astronomical Society, Chesterfield Museum Service, Dronfield Heritage Trust, North East Derbyshire Field Club, Northern Tea Merchants, and the Vicar and PCC of Chesterfield Parish Church for permission to photograph on their premises or use their archive images. All other photos were taken by the author.

Nick Grant, Nikki Embery, Jenny Stephens and Marcus Pennington at Amberley Publishing.

Mum, Dad, Kate, Oscar and Leo for general moral support.

About the Author

Richard Bradley was born in Sheffield and raised at Oaker and Two Dales, near Matlock. He now lives in Sheffield with his partner Kate and two sons. He has written for publications including *Derbyshire Life, Best of British, Record Collector* and *Bad Lib*. He is currently conducting extensive research into Derbyshire folklore and calendar customs.